SRA
LANGUAGE ARTS AND READING

Art Connections

Columbus, OH

The **McGraw·Hill** Companies

Acknowledgments

Cover (tl, cl) Matt Meadows, (bl) Aaron Haupt, (r) ©Geoffrey Clements/Corbis; *10* ©Rick Strange/Index Stock Imagery; *12* ©Stone/Getty Images, Inc.; *14* ©Alinari/Art Resource, NY; *16* ©Chuck Place/Place Stock Photography; *18* ©K. J. Historical/Corbis; *20* ©Christel Gerstenberg/Corbis; *22* ©SuperStock; *24* ©Francis G. Mayer/Corbis; *28* ©Art Archive; *30* ©Bridgeman Art Library; *32* ©Photodisc/Getty Images, Inc.; *34* ©Scala/Art Resource, NY; *36* ©Jacqui Hurst/Corbis; *38* ©James Nazz/Corbis; *40* ©Erich Lessing/Art Resource; *42* ©Mark Fiennes/Bridgeman Art Library; *46* ©Matt Meadows; *48* ©Victoria & Albert Museum, London/Art Resource, NY; *50* ©Leonard de Selva/Corbis; *52* ©ARS/NY/Erich Lessing/Art Resource/NY; *54* ©SuperStock; *56* ©Pam Ingalls/Corbis; *58* ©PhotoDisc/Getty Images; *60* ©Blue Lantern Studio/Corbis; *64* ©Christie's Images/Bridgeman Art Library; *66* ©Christie's Images/Corbis; *68* ©Diana Ong/SuperStock; *70* ©Scala/Art Resource, NY; *72* ©Bridgeman Art Library; *74* ©HIP/Scala/Art Resource, NY; *76* ©Bridgeman Art Library/SuperStock; *78* ©Christie's Images, Inc.

SRAonline.com

 SRA

Send all inquiries to:
SRA/McGraw-Hill
8787 Orion Place
Columbus, OH 43240-4027

Printed in the United States of America.

ISBN 0-07-601880-6

3 4 5 6 7 8 9 RRW 10 09 08 07 06 05

Table of Contents

UNIT 1 • Personal Writing and Poetry

Activity	Level	Page	Warm-Up Page	Technique Tip Page
1 **Phonics:** Letter *A* Object Drawing	PreK	10	80	
2 **Event Sequence:** Paper-Cup Animal Bank	K	12	81	
3 **Setting:** Narrative Painting	1	14	82	
4 **Details:** Clay-Figure Bell	2	16	83	112
5 **Characterization:** Character Greeting Card	3	18	84	
6 **Autobiography:** Life-Sized Paper Doll	4	20	85	
7 **Descriptive Writing:** A Secret Place Painting	5	22	86	
8 **Poetry:** Self-Portrait	6	24	87	

UNIT 2 • Narrative Writing

Activity	Level	Page	Warm-Up Page	Technique Tip Page
1 **Characters:** Craft-Stick Puppet	PreK	28	88	
2 **Alphabet:** Magazine-Cutout Alphabet Book	K	30	89	
3 **Beginning a Story:** Crayon Drawing of a Story Scene	1	32	90	
4 **Figurative Language:** Fantasy Animal Painting	2	34	91	
5 **Descriptive Writing:** Out My Window Collage	3	36	92	
6 **Fantasy:** Fantasy Narrative Painting	4	38	93	
7 **Folklore:** Papier-Mâché Folklore Mask	5	40	94	113
8 **Personal Narrative:** Narrative Self-Portrait Book	6	42	95	

UNIT 3 • Expository Writing

UNIT OPENER

UNIT 4 • Persuasive Writing

UNIT OPENER

Technique Tips

How to Use This Book

What is *Language Arts and Reading Art Connections?*

Language Arts and Reading Art Connections is a series of activities designed to reinforce subject-area studies through visual art and to complement what you are already teaching. By connecting the principles of language arts and reading to the principles of visual arts, students can understand that art touches and shapes their lives in ways they might never have imagined and that the arts and sciences are not separate entities. The activities in this book can be incorporated into classroom studies or serve as culminating activities for specific areas of study.

Art Connections focuses on the basic elements and principles of art, such as line, shape, and texture. *Language Arts and Reading Art Connections* works with these basic principles and relates them specifically to the elements of language arts and reading.

The activities in this book are divided into four units of eight activities each, for a total of thirty-two activities within the discipline. Each activity has a corresponding blackline master that serves as a warm-up to the activity. There is one activity in each unit for grade levels PreK–6, along with suggestions on how to scale up or scale back the activity. Each activity and its corresponding blackline master are based upon curriculum area standards that are common throughout the country. These subject-area and visual arts standards are clearly stated at the end of each activity.

Unit Openers

Each **Unit Opener** presents the subject-area discipline that will be addressed within the unit. A definition and basic overview of the unit concept are provided. Common topics covered within the discipline are shown in two bulleted lists, one for Levels PreK–3, and another for Levels 4–6. Use these lists to develop adaptations of specific activities to areas of study in your classroom.

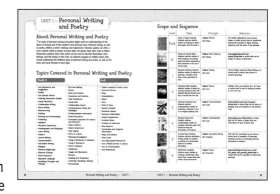

Also included in the **Unit Opener** is a limited **Scope and Sequence** chart that outlines the topic of each activity, provides an explanation of the subject-area and art studies reinforced in each activity, lists the main subject and art principles developed in each activity, and gives an online or print reference to support each activity.

Warm-Ups

The **Warm-Up** pages in the back of the book are blackline masters that serve to focus the student and provide a guided plan for the main activity. They are designed to be seat-based activities and usually require minimal materials.

Each **Warm-Up** page has one subject-related and one art-related **Focus** item—either a question or a statement. The items in Levels PreK–1 are to be read by the teacher and have three answer choices. The items in Levels 2–6 are to be read by the student and have four answer choices. The **Focus** items relate directly to the subject and art objectives within the main activity.

The **Plan** section in the **Warm-Ups** varies with each activity. Most contain some type of graphic organizer or space for sketching ideas. All encourage the student to think critically about the subject-area and/or art objectives for the activity.

Activities

The first page of each activity includes a full-page photograph that can be used to guide the students to focus their designs and an **Art History and Culture** feature that provides interesting facts related to the subject area and activity.

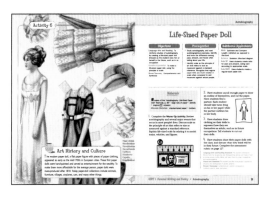

Each activity includes a subject-area objective, a creative expression (visual arts) objective, and two Bloom's Taxonomy competencies that will be met within the activity. At least one of the Bloom's competencies is a critical-thinking skill. Age-appropriate prerequisites for the area of study and the art concept are included. Also included in each activity is an **Additional Applications** feature, which gives ideas for topics in two other subject areas that the activity could support. This feature also includes **Scale Up** and **Scale Back** ideas. The **Scale Up** feature gives a means of adapting the activity for older students and/or adding elements of depth to the activity. The **Scale Back** feature gives a means of adapting the activity for younger students and/or making the activity less complex.

A materials list is provided in each activity, and, in applicable activities, an alternate materials list for adaptations. Directions and illustrations are provided to identify and define the necessary steps of the activity. Subject-area standards, visual arts standards, and Bloom's competencies are clearly stated at the end of each activity.

A photocopy icon ▤ appears within each activity's materials list as a reminder to provide copies of the blackline master. Any materials that might require particular attention in regard to safety are marked with a safety icon ▨. **Technique Tips** are also provided for particular activities where basic background information on specific art processes might be helpful. When a **Technique Tip** is provided, a technique tip icon 🅃🅃 appears at the point of use within the activity. The page number for the appropriate **Technique Tip** can be found in the **Table of Contents** within its respective unit chart next to its corresponding activity. There are also some general **Technique Tips** provided which are not activity-specific. A list of **Technique Tip** titles is also provided on page five of the **Table of Contents.**

Other Features

Elements and Principles of Art Two pages are dedicated to full-color photographic examples of the elements and principles of art.

Accessibility An article on accessibility features information about art in the lives of students with disabilities. School-level resources, disability education organizations, and art education and disability organizations are defined and referenced. Also included is a feature on adapting the art experience for students with disabilities.

Safety An article on safety features information about material labels, guidelines for choosing and using basic art materials in a safe manner, and rules for students to follow while completing art activities.

Assessment Authentic assessment for art is defined through the use of rubrics, portfolios, and self- and peer-assessment in art criticism and aesthetic perception. An assessment rubric is also provided, along with instruction on how to write appropriate art criticism questions using the four-step process of art criticism—*Describe, Analyze, Interpret, Decide.*

Answer Key An answer key is provided on page 128 for the **Focus** and **Plan** items in the **Warm-Ups.**

UNIT 1 • Personal Writing and Poetry

About Personal Writing and Poetry

The study of personal writing and poetry begins with an understanding of the basics of writing and of the student's own personal story. Personal writing, as well as poetry, reflects a writer's feelings and experiences. However, poetry can offer a more creative outlet as poetic structure does not always have strict rules to follow. Elementary students learn that words can be used to describe themselves, their feelings, and the things in their lives. As students progress to middle school, they should understand the different types of personal writing and poetry, as well as the traits and many formats of each type.

Topics Covered in Personal Writing and Poetry

PreK–3

- Use Experience and Imagination
- Details
- Use Specific Words
- Ordering Descriptive Details
- Using Transitions
- Collaborative Writing
- Group Writing
- Brainstorming
- Drafting
- Revising and Proofreading
- Publishing
- Alphabet
- Phonemic Awareness
- Autobiography and Biography
- Letter Writing
- Folklore
- Journal Writing
- Characterization
- Descriptive Writing
- Dialogue
- Effective Beginnings
- Effective Endings
- Event Sequence
- Figurative Language
- Identifying Thoughts and Feelings

- Plot and Setting
- Rhyme
- Book Conventions
- Suspense and Surprise
- Topic Sentences
- Visual Aids
- Collaborative Inquiry
- Comprehension Skills and Strategies
- Finding Needed Information
- Follow Directions
- Formulate Questions for Inquiry and Research
- Make Outlines
- Make Conjectures
- Note Taking
- Parts of a Book
- Planning Investigation
- Using a Dictionary or Glossary
- Using a Thesaurus
- Parts of Speech
- Sentences
- Usage and Mechanics
- Phonics
- Spelling and Vocabulary
- Listening, Speaking, Viewing
- Penmanship

4–6

- Topics Covered in PreK–3 and
- Historical Fiction
- Plays
- Dramatization
- Mood
- Tone
- Point of View
- Sensory Details
- Sentence Variety
- Sentence Elaboration
- Using Comparisons
- Compile Notes
- Conduct an Interview
- Give Reports
- Summarize and Organize Information
- Maps and Globes
- Time Lines
- Use Appropriate Resources
- Use a Media Center or Library
- Use an Encyclopedia
- Use Periodicals

Scope and Sequence

Level	Topic	Principle	Reference
PreK	Letter *A* Object Drawing—Students reinforce phonics studies by drawing an object that begins with the letter *a*.	**Subject:** Phonics **Art:** Shape	*The Hidden Alphabet* by Laura Vaccaro Seeger or similar picture book for grade-level appropriate examples of object drawings beginning with the letters of the alphabet
K	Paper-Cup Animal Bank—Students reinforce studies of event sequence by creating paper-cup banks representing story characters to be put in correct order.	**Subject:** Event Sequence **Art:** Texture	www.piggybankworld.com/**animal_banks.htm** or similar Web site for images of various animal banks
1	Narrative Painting—Students reinforce studies of setting by painting a narrative scene from a story read aloud in class.	**Subject:** Setting **Art:** Color	*The Art Gallery: Stories* by Philip Wilkinson or similar book for history and pictures of narrative paintings
2	Clay-Figure Bell—Students reinforce studies of details by creating clay-figure bells with detailed features formed from clay or incised into the clay.	**Subject:** Details **Art:** Form	*Children, Clay, and Sculpture* by C. W. Topal or similar book for tips on teaching students to work with clay
3	Character Greeting Card—Students reinforce characterization studies by inventing a character to use in an original greeting card.	**Subject:** Characterization **Art:** Unity	www.emotionscards.com/museum/**history.html** or similar Web site for history of greeting cards and examples of old greeting cards
4	Life-Sized Paper Doll—Students reinforce autobiography studies by creating a life-sized paper doll dressed as they see themselves in the future.	**Subject:** Autobiography **Art:** Scale	www.opdag.com/History.html or similar Web site for history of paper dolls and information on types of paper dolls
5	A Secret Place Painting—Students reinforce descriptive writing studies by creating a painting of a secret place based on a written description.	**Subject:** Descriptive Writing **Art:** Emphasis	*Start with Art Landscapes* by Sue Lacey or similar book for examples of landscape paintings and tips on landscape painting techniques for students
6	Self-Portrait—Students reinforce poetry studies by creating a self-portrait using words from a poem they have written about themselves.	**Subject:** Poetry **Art:** Proportion	www.minnetonka.k12.mn.us/cs/Art/**5th_grade_self_portrait_project.htm** or similar Web site for examples of self-portrait paintings

THE HIEROGLYPHIC ALPHABET

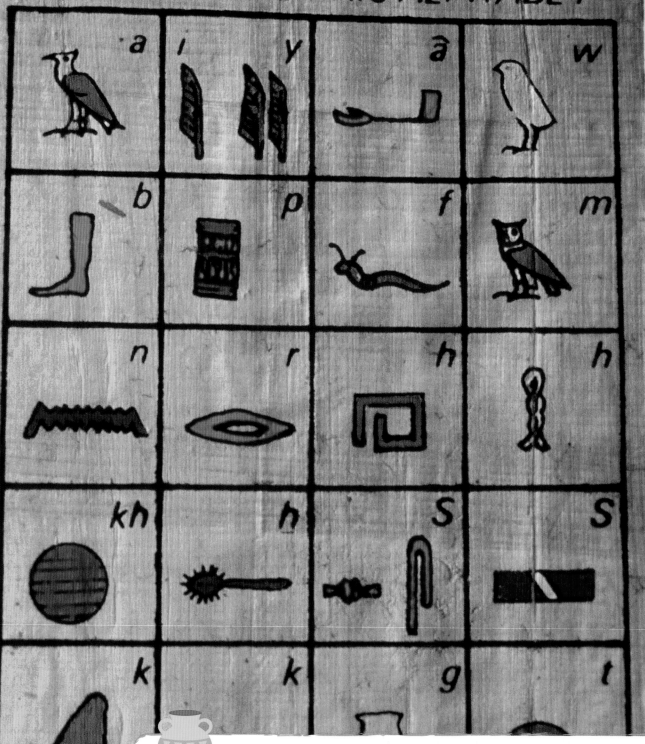

a	i, y	ā	w
b	p	f	m
n	r	h	h
kh	h	S	S
k	k	g	t

Art History and Culture

People have been drawing since prehistoric times. Flint was used to sketch people, animals, things, shapes, and places onto rock walls, and then coal and other earth pigments were used to color the drawings. Ancient Egyptians drew figures to represent ideas and objects. Called *hieroglyphics*, these drawings were often on walls or pottery. Hieroglyphics are one of the oldest forms of writing.

Letter A Object Drawing

Objectives

Language Arts and Reading To reinforce studies of phonics by drawing an object that begins with the letter *a*

Creative Expression To draw two-dimensional objects, using the element of shape

Bloom's Taxonomy Knowledge and Application

Prerequisites

- Study the alphabet, and review phonics. Be familiar with a variety of words that name objects beginning with the letter *a*.
- Look at common shapes, such as circles, squares, and triangles. A shape is flat and can be measured by how tall and wide it is.

Additional Applications

Math Drawing Figures: geometric shapes

Science Living Things: animal drawings

Scale UP Have students draw an object for every letter of their name to put in order.

Scale BACK Have students draw a shape, and write the capital and lowercase letter *a* inside of it.

Materials

📄 copies of the "Phonics: Letter *A* Object Drawing" Warm-Up, p. 80 • an <u>ABC</u> picture book • crayons • drawing paper

Alternate Materials: markers • colored pencils

1. Complete the **Warm-Up Activity.** Read aloud an *ABC* picture book, such as *The Hidden Alphabet* by Laura Vaccaro Seeger, in which pages unfold to reveal letters that are part of the pictures. Review phonics and the letter *a*. Discuss examples of objects that begin with the letter *a*, such as an apple, ant, alligator, airplane, arrow, and so on. Using common geometric shapes, explain the element of shape as a flat, two-dimensional area and how shapes can be drawn to make art.

2. Ask students to think about things that begin with the letter *a*. Give each student a sheet of drawing paper and several crayons.

3. Have students draw their letter *a* object, and color it in.

4. Have students share their drawings with the class, and identify the objects. Complete the assessment rubric on page 127.

Language Arts and Reading Standard: The student identifies and isolates the initial and final sound of a spoken word.
Visual Arts Standard: The student uses visual structures and functions of art to communicate ideas.
Bloom's Taxonomy: Knowledge—observation and recall of information Application—use information

Art History and Culture

Piggy banks have not always looked like pigs. In the Middle Ages, jars made of orange clay called *pygg* were used to store supplies, but often stored money. In the eighteenth century, a potter misunderstood a request to make a pygg bank and instead made a pig-shaped bank. Thus the modern piggy bank was born. Today banks are made to resemble many animals.

Paper-Cup Animal Bank

Objectives

Language Arts and Reading To reinforce studies of event sequence by creating paper-cup character banks from a story read aloud in class, and then placing the banks in the order the characters appear in the story

Creative Expression To create an animal bank with materials that best represent the animal's skin/fur/feathers, using the element of texture

Bloom's Taxonomy Knowledge and Analysis

Prerequisites

• Read aloud in class a simple story that has various animal characters and many pictures, such as *Chicken Little* or *The Little Red Hen.* Be familiar with the story's characters and the order in which they appear.

• Texture is how something feels or looks, such as smooth or bumpy. Look for and compare different textures in the classroom.

Additional Applications

Math Adding Money: counting coins

Science Living Things: animals

Scale UP Have students create papier-mâché animal banks.

Scale BACK Have students cut animal shapes from construction paper to place in sequence.

Materials

📋 copies of the "Event Sequence: Paper-Cup Animal Bank" Warm-Up, p. 81 • paper cups • masking tape • construction paper • fabric scraps of various textures • other textured materials, such as chenille stems, pom-poms, fake fur, and feathers • markers • glue [safety] safety scissors

Alternate Materials: plastic or foam cups • small plastic bottles • googly eyes • papier-mâché paste • newspaper • cardboard tubes • paintbrushes • paint • water containers

1. Complete the **Warm-Up Activity.** Review event sequence and the parts of a story: beginning, middle, and end. Explain that characters might be in all or just some parts of a story. Discuss the element of texture and how animal skins have different textures, including smooth, rough, soft, hard, fuzzy, scaly, and so on. Explain that, in art, materials can be used to imitate the texture of an animal's skin.

2. Give each student two cups to tape together at the open ends with masking tape. Based on the animal each student chose, help students decide whether the cups should sit vertically or horizontally. Then cut a slot for

money in the appropriate place. (This step can be done beforehand if short on time.)

3. Have students choose materials that best mimic their animal's skin/fur/feather texture, and, if needed, trim the materials before students glue them onto their cups. Have students use markers to draw final details.

4. Have students share their animal banks with the class, and tell where in the story their animals appear. Then have students line up their banks in the order the animals appear in the story. Complete the assessment rubric on page 127.

Language Arts and Reading Standard: The student retells or acts out the order of important events in stories.
Visual Arts Standard: The student uses different media, techniques, and processes to communicate ideas, experiences, and stories.
Bloom's Taxonomy: Knowledge—observation and recall of information Analysis—organization of parts

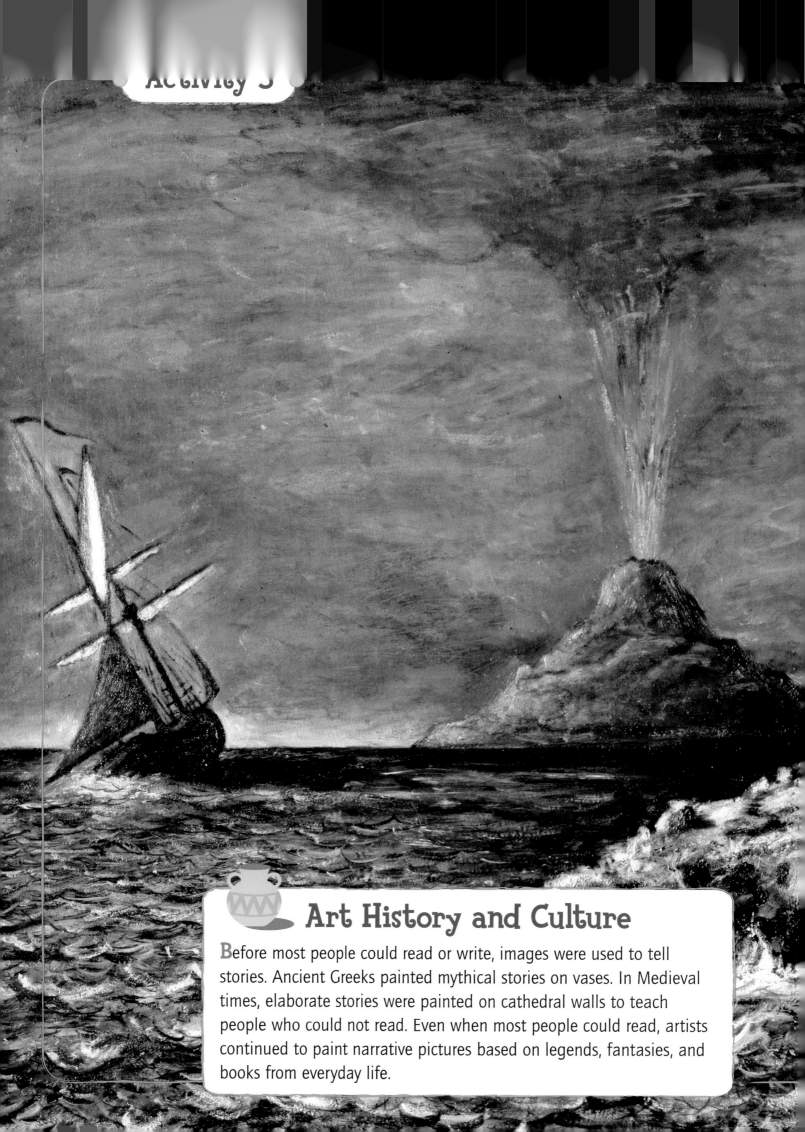

Art History and Culture

Before most people could read or write, images were used to tell stories. Ancient Greeks painted mythical stories on vases. In Medieval times, elaborate stories were painted on cathedral walls to teach people who could not read. Even when most people could read, artists continued to paint narrative pictures based on legends, fantasies, and books from everyday life.

Narrative Painting

Objectives

Language Arts and Reading To reinforce studies of setting by painting a narrative scene from a story read aloud in class

Creative Expression To create a narrative painting, using the element of color and recognizing primary and secondary colors

Bloom's Taxonomy Knowledge and Application

Prerequisites

• Study the traits of narrative writing. Identify setting as the place where a scene happens or where a story takes place.

• Identify primary (red, blue, and yellow) and secondary (orange, green, and purple) colors. Explain that primary colors can be mixed to create secondary colors. Be familiar with the color wheel and how to mix colors.

Additional Applications

Science Environments: types of settings

Social Studies Early Civilizations: narrative about an early civilization

Scale UP Have students create a three-dimensional model of a narrative setting.

Scale BACK Have students draw a picture of a narrative setting.

Materials

📄 copies of the "Setting: Narrative Painting" Warm-Up, p. 82 • paper • red, blue, and yellow paints • paintbrushes • water containers • mixing dishes

Alternate Materials: shoe boxes • construction paper • tape or glue • crayons • markers

1. Complete the **Warm-Up Activity.** Read a short story or a fable that has at least one illustration of a narrative scene. Discuss its setting (indoor, outdoor, forest, city, desert, farm, underwater, and so on) and what makes it a scene (characters and action). Narrative paintings tell a story. Show examples from an art book, such as *The Art Gallery: Stories* by Philip Wilkinson. Review the color wheel (larger portions represent primary colors and smaller portions represent secondary colors). Explain which primary colors can be mixed to create secondary colors. Discuss the correct method for mixing paint colors.

2. Ask students to recall their setting from the **Warm-Up,** and to think of characters (people or animals) to add to tell part of a story.

3. Have students paint their scene.

4. After students' paintings dry, have them share their paintings with the class, and describe the settings. Complete the assessment rubric on page 127.

Language Arts and Reading Standard: The student identifies the importance of the setting to a story's meaning.
Visual Arts Standard: The student selects and uses subject matter, symbols, and ideas to communicate meaning.
Bloom's Taxonomy: Knowledge—observation and recall of information Application—use information

 ## Art History and Culture

Many cultures have long traditions of making clay pottery. The Pueblo, a Native American culture from the southwestern United States, used clay to make adobe bricks for their homes, and to make pots and jugs for cooking and storage. The Pueblo also used clay to make dolls and figures. Today many Pueblo make pottery the same way their ancestors did long ago.

Clay-Figure Bell

Objectives

Language Arts and Reading To reinforce studies of details by creating clay-figure bells that have detailed features formed from or incised into the clay

Creative Expression To create a three-dimensional clay-figure bell, using the element of form

Bloom's Taxonomy Comprehension and Application

Prerequisites

• Study details and how to use adjectives and adverbs to make writing more detailed. Read short stories, and identify the details of one story.

• Identify form as the element of art that is a three-dimensional object measured by height, width, and depth. Recognize that forms have thickness, and can be viewed from more than two sides. Look at clay sculptures and different types of pottery. Be familiar with methods of sculpting clay.

Additional Applications

Science Soil: clay

Social Studies Customs and Traditions: clay sculpture

Scale UP Have students embellish clay-figure bells using texture tools to add more details.

Scale BACK Have students create simple clay bells, and incise figures into them.

Materials

📄 copies of the "Details: Clay-Figure Bell" Warm-Up, p. 83 • terra cotta clay • wax paper • rolling pins or wooden dowels [Safety] plastic knives, toothpicks, and craft sticks

1. Complete the **Warm-Up Activity.** Discuss a story's details and how written details compare to details in art. Explain the element of form as a three-dimensional object measured by height, width, and depth that can be viewed from more than two sides. To point out details, share an art book, such as *The Pueblo: Southwestern Potters* by Mary Englar.

2. Have students cover their workspace with wax paper. Give each student two balls of clay. Tell them to form one ball into a bell using the pinch pot technique (thumbs push in middle of clay to form a hollow). Have students split the other ball in two parts, and use one part to mold a head. Have them form the other part into two arms and the bell's clapper. At their bell's top, have students make a small hole in the center to hang the clapper.

3. Using plastic knives, toothpicks, and craft sticks, have students carve details into the clay, such as facial features, hair, and clothing patterns based on their **Warm-Up** plans. Have students score and slip the arms and head. Then fire the clay bells, or let them air dry. 🔵

4. Have students share their bells with the class, and explain why they chose their details. Complete the assessment rubric on page 127.

Language Arts and Reading Standard: The student draws and discusses visual images based on text description.
Visual Arts Standard: The student uses visual structures and functions to communicate ideas.
Bloom's Taxonomy: Comprehension—understanding information Application—use methods, concepts, theories in new situations

MEMORIAL·DAY· GREETINGS

Art History and Culture

The oldest-known greeting card is a valentine from the 1400s. Sending greeting cards did not really become popular until the early 1800s. These early greeting cards were either homemade or created by an artist, which made the cards quite expensive. By the 1850s, however, greeting cards were being mass-produced by machines and became more affordable. Today many graphic artists design greeting cards.

Character Greeting Card

Objectives

Language Arts and Reading To reinforce studies of characterization by inventing a character to use in an original greeting card

Creative Expression To create a greeting card in which the front and the inside of the card show the principle of unity in some way

Bloom's Taxonomy Comprehension and Synthesis

Prerequisites

- Study characterization. Be familiar with different types of characters.
- Recognize unity as the principle of art that is the feeling of wholeness or oneness achieved by properly using other art principles and elements. Be familiar with greeting cards and their structure of a front and an inside, which must be related in some way.

Additional Applications

Science Feelings: cards to express feelings

Social Studies Holidays: holiday cards

Scale UP Have students create a picture book using an invented character.

Scale BACK Have students draw an invented character on paper.

Materials

📄 copies of the "Characterization: Character Greeting Card" Warm-Up, p. 84 • paper (construction paper or thicker) • pencils • markers
Alternate Materials: crayons [Safety!] stapler and staples

1. Complete the **Warm-Up Activity.** Make sure students understand they are not re-creating an existing character, but inventing their own character based on imagination, inspiration from literature, and so on. Review characterization and various character traits, such as helpful or unkind. A helpful character could be shown doing a good deed with a content look on his or her face. An unkind character could be shown with an angry facial expression. Use some student-invented characters for examples of characterization. Discuss unity and ways to create unity between the front and the inside of a greeting card.

2. Give each student one sheet of paper to fold in half.

3. Using pencils, have students draw their character and write a message according to their design from the **Warm-Up.** Then have students color in their design with markers.

4. Have students share their cards with the class. Students should discuss what makes their character unique and how they showed the traits of their character. Complete the assessment rubric on page 127.

Language Arts and Reading Standard: The student analyzes characters, including their traits, feelings, relationships, and changes.
Visual Arts Standard: The student uses visual structures and functions of art to communicate ideas.
Bloom's Taxonomy: Comprehension—translate knowledge into new context
Synthesis—relate knowledge from several areas

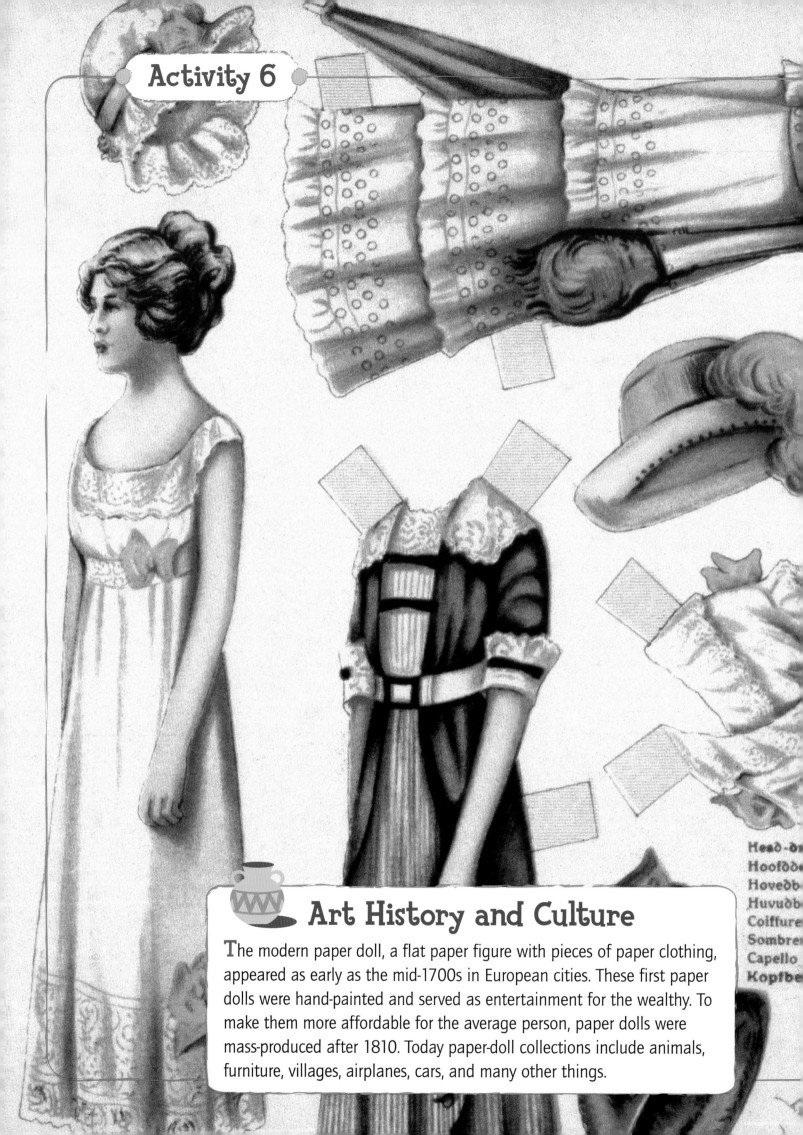

Art History and Culture

The modern paper doll, a flat paper figure with pieces of paper clothing, appeared as early as the mid-1700s in European cities. These first paper dolls were hand-painted and served as entertainment for the wealthy. To make them more affordable for the average person, paper dolls were mass-produced after 1810. Today paper-doll collections include animals, furniture, villages, airplanes, cars, and many other things.

Head-dr
Hoofdde
Hovedb-
Huvudb-
Coiffure
Sombre
Capello
Kopfbe

Life-Sized Paper Doll

Objectives

Language Arts and Reading To reinforce studies of autobiography by creating a life-sized paper doll dressed as the student sees him or herself in the future, such as in an occupation

Creative Expression To make a life-sized paper doll, using the principle of scale

Bloom's Taxonomy Comprehension and Synthesis

Prerequisites

• Study autobiography, and read autobiographical examples. Identify and know the difference among past, present, and future when telling about your life.

• Identify scale as the principle of art that refers to size as measured against a standard reference. Recognize that regular paper dolls are much smaller in scale when compared to and measured against actual people.

Additional Applications

Math Estimate and Compare Length: miniature as opposed to life-sized

Science Skeleton: life-sized diagram

Scale UP Have students create dolls for past and present, sizing each according to appropriate scale.

Scale BACK Have students create a regular-sized paper doll.

Materials

📄 copies of the "Autobiography: Life-Sized Paper Doll" Warm-Up, p. 85 • large rolls of paper • pencils • crayons [Safety!] scissors

Alternate Materials: standard-sized paper • markers

1. Complete the **Warm-Up Activity.** Review autobiography and several major events that occur in most people's lives. Discuss scale as the principle of art that refers to size as measured against a standard reference. Explain life-sized scale by relating it to model trains, vehicles, and figures.

2. Have students unroll enough paper to draw an outline of themselves, and cut the paper. Have students find a partner. Each student should take turns lying on his or her paper while the partner outlines his or her body.

3. Have students draw clothing on their dolls to represent how they see themselves as adults, such as in future occupations. Tell students to cut out their dolls.

4. Have students share their paper dolls with the class, and discuss what they think will be in their future. Complete the assessment rubric on page 127.

Language Arts and Reading Standard: The student understands literary forms by recognizing and distinguishing among such types of text as stories, poems, myths, fables, tall tales, limericks, plays, biographies, and autobiographies.
Visual Arts Standard: The student describes how people's experiences influence the development of specific artworks.
Bloom's Taxonomy: Comprehension—predict consequences Synthesis—predict, draw conclusions

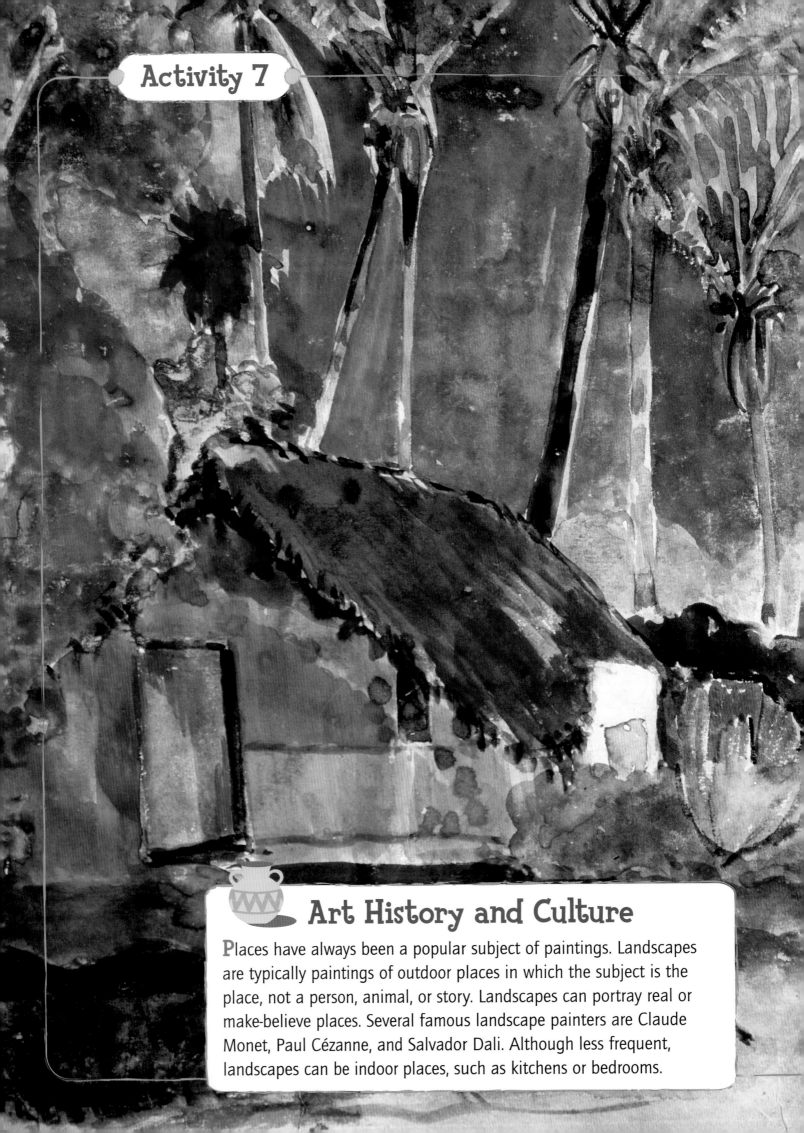

Art History and Culture

Places have always been a popular subject of paintings. Landscapes are typically paintings of outdoor places in which the subject is the place, not a person, animal, or story. Landscapes can portray real or make-believe places. Several famous landscape painters are Claude Monet, Paul Cézanne, and Salvador Dali. Although less frequent, landscapes can be indoor places, such as kitchens or bedrooms.

Fantasy Animal Painting

Objectives

Language Arts and Reading To reinforce studies of figurative language by painting a fantasy animal based on a figurative sentence

Creative Expression To create a painting that incorporates contrasting colors, using the principle of variety

Bloom's Taxonomy Comprehension and Synthesis

Prerequisites

- Study figurative language. Be able to recognize types of figurative language such as simile, metaphor, hyperbole, and personification. Practice writing sentences using figurative language.

- Identify variety as the principle of art that is concerned with difference or contrast. Analyze paintings that use variety, and consider ways to achieve variety in art, such as using contrasting colors or shapes.

Additional Applications

Math Drawing Figures: fantasy animal, using geometric figures

Science Environments: fantasy environments

Scale UP Have students create a fantasy animal, papier-mâché sculpture.

Scale BACK Have students draw a fantasy animal.

Materials

📄 copies of the "Figurative Language: Fantasy Animal Painting" Warm-Up, p. 91 • paper • brightly-colored paints • paintbrushes • water containers • permanent, black nontoxic markers • resources with photographs of real animals

Alternate Materials: cardboard • cardboard tubes • tape • papier-mâché paste • crayons • newspaper

1. Complete the **Warm-Up Activity.** Review figurative language and give examples. Show age-appropriate examples of fantasy paintings of animals; use a Greek mythology reference. Discuss the principle of variety as the difference or contrast in artwork, and explain how using contrasting colors in a painting results in variety.

2. For visual research, allow students to look at animal photos. On paper, have students draw the fantasy animals they described in the **Warm-Up's** figurative sentence, and then outline the animals with black markers.

3. Give each student paint, a paintbrush, and a water container to paint their fantasy animal outline.

4. Have students share their fantasy animal paintings with the class, and explain how they expressed figurative language through painting. Complete the assessment rubric on page 127.

Language Arts and Reading Standard: The student composes sentences with interesting, elaborated subjects.
Visual Arts Standard: The student uses different media, techniques, and processes to communicate ideas, experiences, and stories.
Bloom's Taxonomy: Comprehension—grasp meaning Synthesis—use old ideas to create new ones

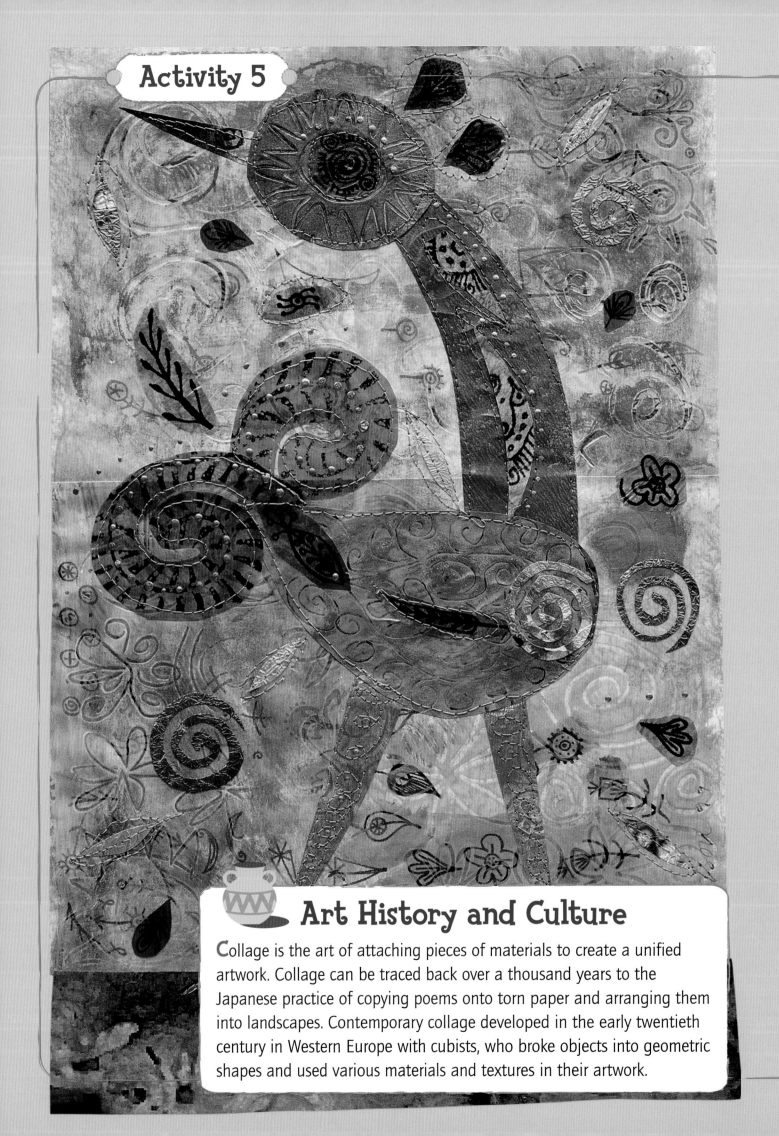

Art History and Culture

Collage is the art of attaching pieces of materials to create a unified artwork. Collage can be traced back over a thousand years to the Japanese practice of copying poems onto torn paper and arranging them into landscapes. Contemporary collage developed in the early twentieth century in Western Europe with cubists, who broke objects into geometric shapes and used various materials and textures in their artwork.

Out My Window Collage

Objectives

Language Arts and Reading To reinforce studies of descriptive writing by creating a collage based on a description of what the student would see or dream about when looking outside his or her bedroom window

Creative Expression To create a paper collage in which close objects are larger than distant objects while utilizing the principle of perspective

Bloom's Taxonomy Comprehension and Analysis

Prerequisites

• Study traits of descriptive writing. Read descriptive story passages. Practice writing descriptive sentences.

• Recognize perspective as a system in art used to create the illusion of depth and volume on a flat surface. Analyze artworks that use perspective. Note that one way to achieve perspective is to make close objects larger and distant objects smaller.

Additional Applications

Science Plants: garden scene in perspective

Social Studies Washington, D.C.: national monuments in perspective

Scale UP Have students create a window with shutters that open to reveal a collage.

Scale BACK Have students draw a window with a view showing one object far away.

Materials

📄 copies of the "Descriptive Writing: Out My Window Collage" Warm-Up, p. 92 • white, heavy drawing paper • construction paper • age-appropriate magazines • wallpaper, wallpaper books • gift wrap • glue • thin, black nontoxic markers 〔Safety!〕 scissors

1. Complete the **Warm-Up Activity.** Review descriptive writing, how artwork can be based on descriptive writing, and how descriptive writing can be based on artwork. Discuss the principle of perspective as the system used to create the illusion of depth and volume on a flat surface. Explain how perspective can be achieved in a collage by making objects in the foreground larger than objects in the background.

2. Have students start with a sheet of white paper for their collage background. Based on their descriptions from the **Warm-Up,** have students sketch their out-of-window scenes while minding the rules of perspective. Then have them cut out shapes from scraps of wallpaper, gift wrap, magazines, and construction paper. The cutouts should be what students see out the "window." Remembering perspective, students should glue their cutouts into place.

3. After their collage is made, any other details can be drawn in using black marker. Have students cut strips out of construction paper, and glue them onto their collage to create the window frame and border.

4. Have students share their collages with the class, and explain what they "see." Compare any fantasy collages to real ones. Complete the assessment rubric on page 127.

Language Arts and Reading Standard: The student writes to record ideas and reflections.
Visual Arts Standard: The student selects and uses subject matter, symbols, and ideas to communicate meaning.
Bloom's Taxonomy: Comprehension—translate knowledge into new context Analysis—organization of parts

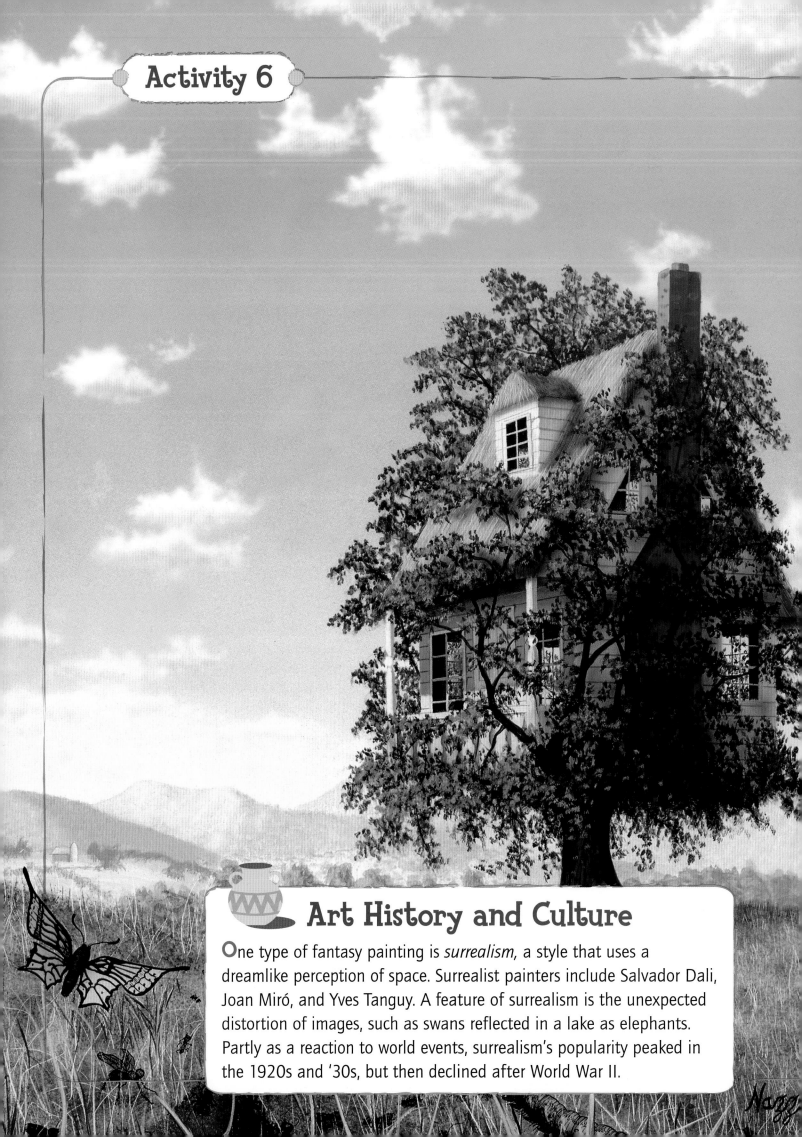

Art History and Culture

One type of fantasy painting is *surrealism*, a style that uses a dreamlike perception of space. Surrealist painters include Salvador Dali, Joan Miró, and Yves Tanguy. A feature of surrealism is the unexpected distortion of images, such as swans reflected in a lake as elephants. Partly as a reaction to world events, surrealism's popularity peaked in the 1920s and '30s, but then declined after World War II.

Fantasy Narrative Painting

Objectives

Language Arts and Reading To reinforce studies of fantasy by creating a fantasy narrative painting and then writing a story based on the painting

Creative Expression To experiment with unusual proportions in a painting while applying the principle of distortion

Bloom's Taxonomy Comprehension and Application

Prerequisites

• Read examples of fantasy stories, and review the traits, or elements, of fantasy.

• Identify distortion as the principle of art that is a deviation from normal or expected proportions. Compare and contrast proportion and distortion. Look at artwork examples that use distortion, such as the work of Frida Kahlo or Pablo Picasso.

Additional Applications

Science Sleep: dreams as fantasy

Social Studies Ancient Greece: mythology as fantasy

Scale UP Have students create a clay-tile fantasy scene.

Scale BACK Have students draw a fantasy scene.

Materials

📄 copies of the "Fantasy: Fantasy Narrative Painting" Warm-Up, p. 93 • drawing paper • notebook paper • pencils • paint • paintbrushes • water containers

Alternate Materials: clay • craft sticks

1. Complete the **Warm-Up Activity.** Review fantasy. Discuss how fantasy comes from one's imagination and has no limits. Explain the principle of distortion and how it can be achieved by changing the expected appearance of an object, such as drawing a face with square eyes or sculpting a tree growing out of a chair. Analyze artwork that utilizes distortion, such as creations by Joan Miró, Yves Tanguy, or Salvador Dali.

2. Give students pencils and drawing paper to first sketch their fantasy scenes based on their plans from the **Warm-Up.** Explain that at least one area of their scene should achieve distortion.

3. Give students paint, paintbrushes, and water containers, and have them add detail to their fantasy scenes. As paintings dry, have students write short stories based on their paintings.

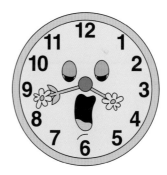

4. Have students share their fantasy paintings with the class, and read aloud part or all of their short stories. Complete the assessment rubric on page 127.

Language Arts and Reading Standard: The student writes to express, discover, record, develop, reflect on ideas, and to problem solve.
Visual Arts Standard: The student uses visual structures and functions of art to communicate ideas.
Bloom's Taxonomy: Comprehension—translate knowledge into new context
Application—use information

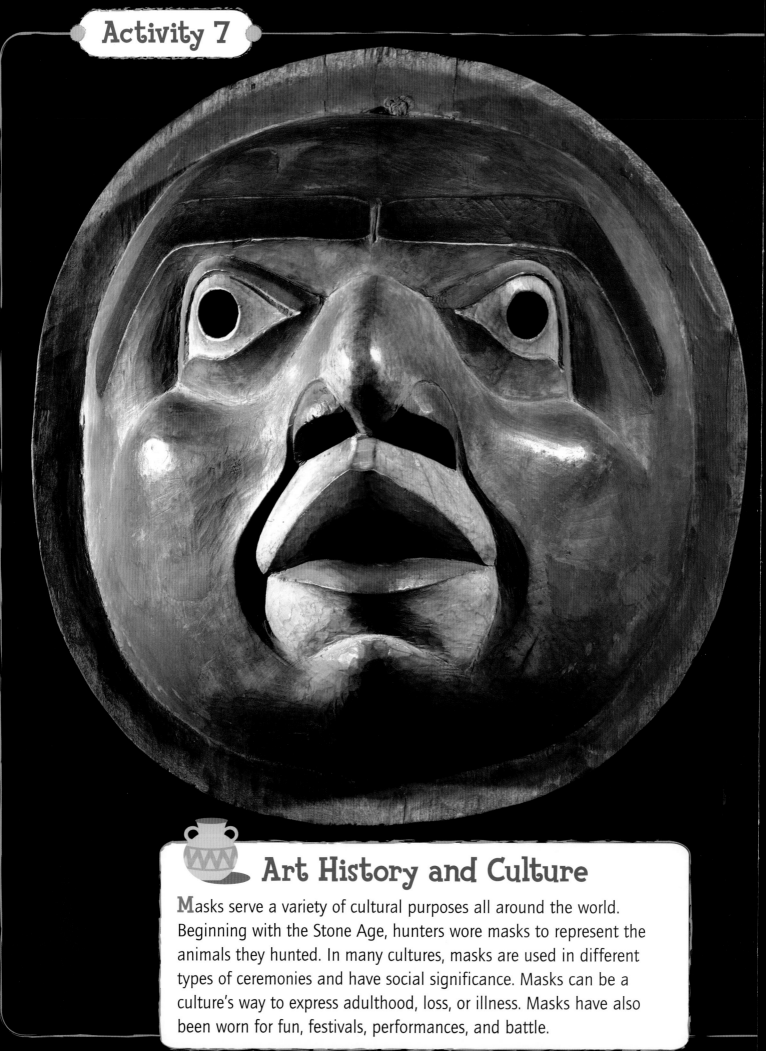

Art History and Culture

Masks serve a variety of cultural purposes all around the world. Beginning with the Stone Age, hunters wore masks to represent the animals they hunted. In many cultures, masks are used in different types of ceremonies and have social significance. Masks can be a culture's way to express adulthood, loss, or illness. Masks have also been worn for fun, festivals, performances, and battle.

Papier-Mâché Folklore Mask

Objectives

Language Arts and Reading To reinforce studies of folklore by creating a papier-mâché folklore mask based on folklore read in class

Creative Expression To create a papier-mâché surface while applying the principle of texture

Bloom's Taxonomy Knowledge and Application

Prerequisites

• Read examples of folklore from different cultures, such as African, North American, and South American. Discuss any common folklore traits each culture shares. Explain that many cultures communicate folklore orally.

• Identify texture as the element of art that refers to how things feel or look as if they might feel if touched.

Additional Applications

Math Symmetry: facial symmetry

Social Studies History of World Religions: ceremonial masks

Scale UP Have students use colored pencil rubbings to create texture in a book with drawings of masks from at least three cultures.

Scale BACK Have students use construction-paper scraps to create different textures on a folklore mask.

Materials

copies of the "Folklore: Papier-Mâché Folklore Mask" Warm-Up, p. 94 • paper plates • posterboard • construction paper • glue • [Safety!] scissors • newspaper [Safety!] stapler and staples • papier-mâché paste or thinned white glue • paint • paintbrushes • water containers

Alternate Materials: wallpaper • gift wrap • yarn • tape • cultural reference books

1. Complete the **Warm-Up Activity.** Review folklore examples, and discuss typical folklore characters. Define texture as the element of art that refers to how things feel or look as if they might feel if touched. Explain that one way to achieve texture is to create raised lines and patterns with papier-mâché. Show examples of folklore masks.

2. Have students cut paper plates into mask shapes. A small triangular notch should also be cut into the top and bottom of the mask. Additional features, such as eyes, ears, noses, and horns, can be cut into the masks or made from posterboard and paper plate scraps to be glued to the masks. Have students recreate texture from the **Warm-Up.** With a slight fold, staple the masks at the notches to create depth.

3. Have students dip newspaper strips into papier-mâché paste, wipe off the excess, and apply them to the masks. Students should build around facial features to accentuate them, and repeat until their masks are covered to create raised, textured lines. After masks dry, have students add patterns and details with construction-paper scraps and/or paint to decorate them. **T꜀**

4. Have students share their folklore masks with the class, and tell if their masks are invented or based on a story. Complete the assessment rubric on page 127.

Language Arts and Reading Standard: The student reads to increase knowledge of his/her own culture, the culture of others, and the common elements of cultures.
Visual Arts Standard: The student selects and uses the qualities of structures and functions of art to improve communication of his/her ideas.
Bloom's Taxonomy: Knowledge—observation and recall of information Application—use information

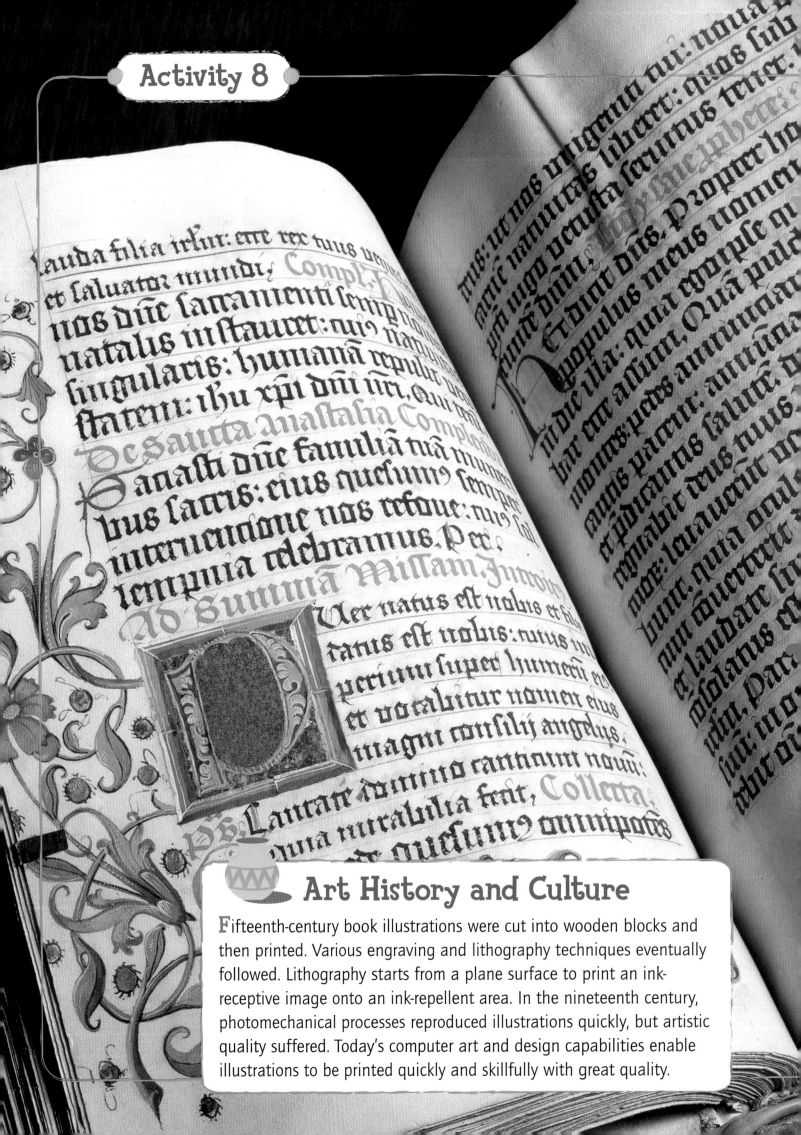

Art History and Culture

Fifteenth-century book illustrations were cut into wooden blocks and then printed. Various engraving and lithography techniques eventually followed. Lithography starts from a plane surface to print an ink-receptive image onto an ink-repellent area. In the nineteenth century, photomechanical processes reproduced illustrations quickly, but artistic quality suffered. Today's computer art and design capabilities enable illustrations to be printed quickly and skillfully with great quality.

Narrative Self-Portrait Book

Objectives

Language Arts and Reading To reinforce studies of personal narrative as students draw themselves as the main character in a personal narrative book

Creative Expression To create a book that develops a self–portrait with words and images while applying the principle of balance

Bloom's Taxonomy Comprehension and Analysis

Prerequisites

- Read examples of personal narratives and study some of their common traits. Practice writing brief personal narratives.
- Identify balance as the principle of design that deals with visual weight in an artwork. Analyze examples of balanced artwork.

Additional Applications

Science Space Exploration: illustrated narrative about going to space

Social Studies Countries: illustrated travel diary

Scale UP Have students plan a book's layout by using a computer program and its graphics.

Scale BACK Have students draw a picture to accompany a personal narrative.

Materials

copies of the "Personal Narrative: Narrative Self-Portrait Book" Warm-Up, p. 95 • 8 1/2" × 11" white paper cut in halves • construction paper • pencils with erasers • colored pencils • hole punch • string or yarn

Alternate Materials: computer(s) [Safety!] stapler and staples

1. Complete the **Warm-Up Activity.** Review personal narrative. Discuss balance as it applies to writing; for example, having story pages that do not have too much text or too many images. In art, explain balance as the principle of design that deals with visual weight. Visual weight does not refer to a measurement but what a viewer first sees in an artwork. Size, color, shape, and contour affect visual weight. Show examples of stories or books that have balanced the visual weight of text with illustrations, such as *Freckle Juice* by Judy Blume.

2. Using themselves as the main character, give students white paper and pencils to write and illustrate their story. Remind students to apply the principle of balance. Add detail to illustrations with colored pencils.

3. Have students choose a color of construction paper to fold in half for their cover, and then write their title on the cover. Put the pages inside the cover. Make three holes down the left side, weave string through the holes and tie, or staple the book together.

4. Have students read all or part of their books and share their illustrations. Complete the assessment rubric on page 127.

Language Arts and Reading Standard: The student writes to express, discover, record, develop, reflect on ideas, and to problem solve.
Visual Arts Standard: The student integrates visual, spatial, and temporal concepts with content to communicate intended meaning in his/her artworks.
Bloom's Taxonomy: Comprehension—translate knowledge into new context
Analysis—organization of parts

UNIT 3 • Expository Writing

About Expository Writing

The study of expository writing begins with an understanding of its purpose: to explain, to inform, or to describe a process. Elementary students first learn how to define a simple term or an idea. As students progress, they learn advanced forms of exposition, such as compare and contrast and cause and effect. Students also learn how to write summaries, essays, and responses to nonfiction. In middle school, students should be able to compose more complex exposition by using varied and elaborate sentences, as well as comparisons.

Topics Covered in Expository Writing

PreK-3

- Define a Term or an Idea
- Compare and Contrast
- Explaining a Process
- Cause and Effect
- Write a Summary
- Write a Response to Nonfiction
- Write an Essay
- Collaborative Writing
- Group Writing
- Brainstorming
- Drafting
- Revising
- Proofreading
- Publishing
- Descriptive Writing
- Informational Text
- Effective Beginnings
- Effective Endings
- Event Sequence
- Figurative Language
- Identifying Thoughts and Feelings
- Suspense and Surprise
- Topic Sentences
- Visual Aids
- Collaborative Inquiry
- Communicating Research Progress Results

- Finding Needed Information
- Follow Directions
- Formulate Questions for Inquiry and Research
- Make Outlines
- Make Conjectures
- Note Taking
- Parts of a Book
- Planning Investigation
- Using a Dictionary or Glossary
- Using a Thesaurus
- Parts of Speech
- Sentences
- Usage
- Mechanics
- Spelling
- Listening
- Speaking
- Viewing
- Penmanship
- Book Conventions
- Phonemic Awareness
- Alphabet
- Phonics
- Comprehension Strategies
- Comprehension Skills
- Vocabulary

4-6

- Topics Covered in PreK–3 and
- Mood
- Tone
- Point of View
- Sensory Details
- Sentence Variety
- Sentence Elaboration
- Using Comparisons
- Compile Notes
- Conduct an Interview
- Give Reports
- Summarize and Organize Information
- Maps and Globes
- Time Lines
- Use Appropriate Resources
- Use a Media Center or Library
- Use an Encyclopedia
- Use Periodicals

Scope and Sequence

Level	Topic	Principle	Reference
PreK	School Sign—Students reinforce studies of visual aids by creating a sign for school that communicates directions, safety, or other helpful information.	**Subject:** Visual Aids **Art:** Harmony	**www.nysgtsc.state.ny.us/kidsign.htm** or similar Web site for images of helpful signs
K	Paper-Plate Puppet—Students reinforce studies of group writing by writing a story as a group about the ocean, and creating puppets as story characters.	**Subject:** Group Writing **Art:** Form	**www.allaboutspace.com/coloring/oceanlife.shtml** or similar Web site for examples of pictures of ocean animals
1	Wild Animal Cutout—Students reinforce studies of sentences by writing a sentence about a wild animal and creating a construction paper cutout based on the animal.	**Subject:** Sentences **Art:** Space	**www.kidsgowild.com/** or similar Web site for factual information about animals in their natural and wild habitats
2	Magazine Collage—Students reinforce studies of brainstorming by writing a story based on three random magazine images.	**Subject:** Brainstorming **Art:** Unity	**www.artlex.com/ArtLex/c/collage.html** or similar Web site for examples of collages by famous artists
3	Narrative Drawing—Students reinforce studies of descriptive writing by writing about a favorite memory, and then drawing a picture that tells the story of that memory.	**Subject:** Descriptive Writing **Art:** Value	**www.deweycolorsystem.com/mycolors/mycolors.htm** or similar Web site for a quiz associating color with personality
4	Oil Pastel of a Chair—Students reinforce studies of group writing by composing a group story about a chair, and then creating an oil pastel drawing based on the story.	**Subject:** Group Writing **Art:** Perspective	**www.jeangroberg.com/pages/gallery-1-1-0-.php** or similar Web site for examples of paintings of chairs
5	Cartoon Storyboard—Students reinforce studies of event sequence by creating a cartoon storyboard that shows the sequence of a story.	**Subject:** Event Sequence **Art:** Distortion	**www.geocities.com/mastercartoonist2000/cartooning_lessons.htm** or similar Web site for step-by-step instructions on cartooning for children
6	Story Illustration—Students reinforce studies of publishing by completing the main stages of publishing a children's book.	**Subject:** Publishing **Art:** Emphasis	**www.childrensbooksonline.org/library.htm** or similar Web site for text and illustrations of vintage or antique children's books

operated door
To hold car
at floor

With doors open, turn key to "HOLD"

nd

With doors open, turn key to "OFF"

 Activity 1

CALL
CANCEL

 3 **4**

 ☆**1** **2**

Art History and Culture

Even though there are many established languages, individual symbols remain invaluable to communication. Our daily lives and activities are filled with symbols. Commonly recognized letters, characters, and icons are especially effective and beneficial when there is little space to communicate a message. To represent human expression in artwork, artists often incorporate symbols and language, such as Japanese calligraphy, Roman alphabet letters, arrows, newsprint, and Braille.

School Sign

Objectives

Language Arts and Reading To reinforce studies of visual aids by creating a sign for school that communicates directions, safety, or other helpful information

Creative Expression To create a school sign while applying the principle of harmony

Bloom's Taxonomy Knowledge and Application

Prerequisites

- Study different types of visual aids, such as street and traffic signs, maps, and charts.
- Look for shapes, colors, and textures that are repeated in everyday settings. Look for the same things in a book of art.

Additional Applications

Science Emergency Care: hospital symbols

Social Studies Direction: using signs to get somewhere

Scale UP Have students create a sign by cutting a shape out of posterboard and using colored construction paper and markers in the same color family to communicate a message.

Scale BACK Have students draw three different sign shapes.

Materials

📄 copies of the "Visual Aids: School Sign" Warm-Up, p. 96 • drawing paper • crayons

Alternate Materials: posterboard • construction paper • markers • glue [safety] safety scissors

1. Complete the **Warm-Up Activity.** Review visual aids and why they are helpful. Ask students to think of common visual aids, such as transparencies, bathroom signs, graphs, and pictures that are used to describe a process. Explain that harmony is the principle of art that creates unity by stressing similarities of separate but related parts. Harmony can be achieved in two-dimensional artwork by repeating a shape, a color, or a texture. For example, when something uses different values of the same color (a light blue and a dark blue), it achieves harmony.

2. Remembering the purpose (or the message) of their signs, ask students to select a shape for their sign from the **Warm-Up,** and then sketch it onto drawing paper.

3. Have students choose either red, orange, yellow, green, blue, or purple. To achieve harmony, tell students to use crayons that are light and dark versions of the color they chose to put their message onto and decorate their sign. It is expected that student messages will use symbols, but they may attempt to write words.

4. Have students share their signs with the class. Complete the assessment rubric on page 127.

Language Arts and Reading Standard: The student records or dictates his/her own knowledge of a topic in various ways such as by drawing pictures, making lists, and showing connections between ideas.
Visual Arts Standard: The student selects and uses subject matter, symbols, and ideas to communicate meaning.
Bloom's Taxonomy: Knowledge—knowledge of major ideas Application—use methods, concepts, theories in new situations

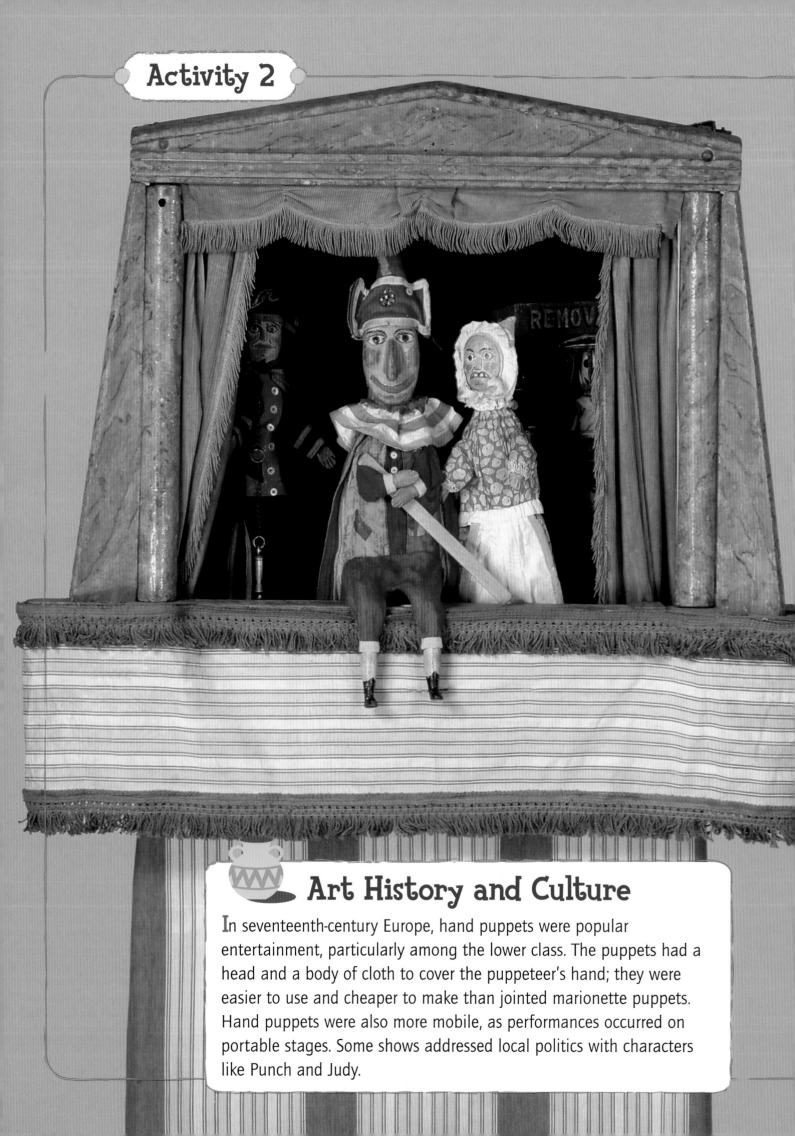

Art History and Culture

In seventeenth-century Europe, hand puppets were popular entertainment, particularly among the lower class. The puppets had a head and a body of cloth to cover the puppeteer's hand; they were easier to use and cheaper to make than jointed marionette puppets. Hand puppets were also more mobile, as performances occurred on portable stages. Some shows addressed local politics with characters like Punch and Judy.

Paper-Plate Puppet

Objectives

Language Arts and Reading To reinforce studies of group writing by writing a story as a group about the ocean, and creating puppets as story characters

Creative Expression To create a three-dimensional paper-plate puppet by using the element of form

Bloom's Taxonomy Comprehension and Synthesis

Prerequisites

• Study group writing. Practice getting, sharing, saving (such as in a list or with drawings), and writing ideas in a group setting.

• Look for objects that can be measured by how tall they are, how wide they are, and how deep they are. Such objects have thickness and can be viewed from more than two sides.

Additional Applications

Science Dinosaurs: dinosaur puppets

Social Studies Early Civilizations: Asia, Chinese shadow puppets

Scale UP Have students think of their own story, and make puppets for each character.

Scale BACK Have students create a paper puppet based on him or herself or a family member.

Materials

📋 copies of the "Group Writing: Paper-Plate Puppet" Warm-Up, p. 97 • paper plates, 2 per student
🖍 safety scissors • tape • construction paper • glue

1. Complete the **Warm-Up Activity.** Review group writing, and discuss some of its methods. Define form as a three-dimensional object that is measured by height, width, and depth. Explain that a puppet is a form because it is not flat like a drawing, and it can be viewed from more than two sides. Compare and comprehend the difference between form (three-dimensional art, such as sculpture) and shape (two-dimensional art, such as a sketch).

2. Have one student start an ocean story based on the **Warm-Up.** Encourage students to consider their characters. Write the first

student's sentence or idea on the board. Repeat the process with each student. Read aloud the completed story to the class.

3. With the plate bottoms facing out, have students tape their plates together two-thirds of the way around. Have them trim off the untaped portion, leaving an opening big enough for a hand. For puppet details, have students glue on construction paper shapes. Encourage them to use cutting techniques to add dimensional detail such as ears, hair, and horns. 🖼

4. Have students share their puppets with the class, and describe their characters. Have students raise their puppets when the corresponding character appears as the story is reread aloud. Complete the assessment rubric on page 127.

Language Arts and Reading Standard: The student composes original texts as he/she dictates messages such as news and stories for others to write.
Visual Arts Standard: The student uses different media, techniques, and processes to communicate ideas, experiences, and stories.
Bloom's Taxonomy: Comprehension—translate knowledge into new context
Synthesis—relate knowledge from several areas

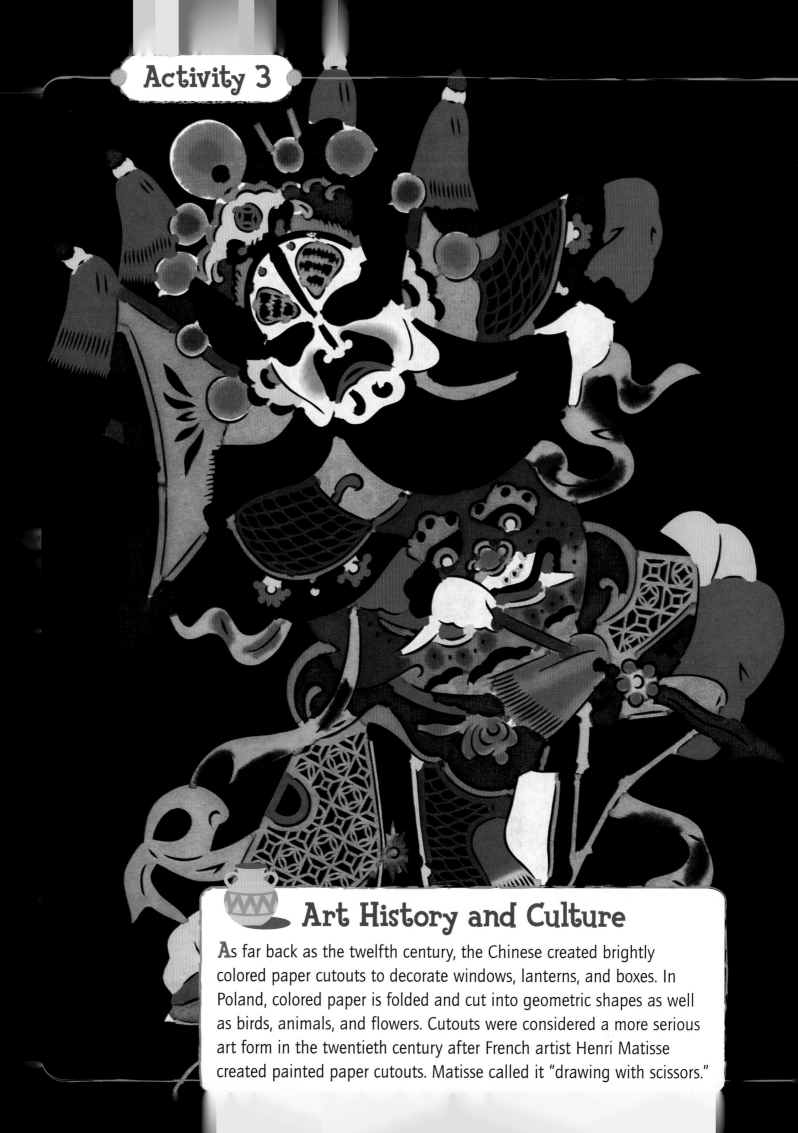

Art History and Culture

As far back as the twelfth century, the Chinese created brightly colored paper cutouts to decorate windows, lanterns, and boxes. In Poland, colored paper is folded and cut into geometric shapes as well as birds, animals, and flowers. Cutouts were considered a more serious art form in the twentieth century after French artist Henri Matisse created painted paper cutouts. Matisse called it "drawing with scissors."

Wild Animal Cutout

Objectives

Language Arts and Reading To reinforce studies of sentences by writing a sentence about a wild animal, and creating a construction paper cutout based on the sentence's animal

Creative Expression To create a construction paper cutout, using the element of space

Bloom's Taxonomy Comprehension and Synthesis

Prerequisites

• Read examples of different types of sentences, such as declarative (states something), imperative (commands), interrogative (asks), and exclamatory (expresses strong feeling). Practice writing simple sentences.

• Identify space as the element of art that refers to the areas above, below, between, within, and around an object. Look at paper cutout artwork.

Additional Applications

Math States: state cutouts

Science Food: fruit and vegetable cutouts

Scale UP Have students write a story, and make cutouts to show story sequence.

Scale BACK Have students write an object word, and draw a picture of it.

Materials

📄 copies of the "Sentences: Wild Animal Cutout" Warm-Up, p. 98 • construction paper • pencils • colored pencils • glue 🔖 safety scissors

Alternate Materials: drawing paper • crayons

1. Complete the **Warm-Up Activity.** Review sentence types and how to write an example of each (see **Prerequisites**). Define the art element of space as the areas above, below, between, within, and around an object. Examine artwork with much open space. Explain that in a paper cutout, the part that is cut out is space. Discuss the use of space in simple paper cutouts by artists such as Henri Matisse.

2. On construction paper, have students lightly draw the animal and any other people or objects from their sentences from the **Warm-Up.** All parts of the drawings should be connected.

3. While maintaining the cutout as one piece, have students cut *around* their drawing, and then cutout any space *within* their drawing. Have them glue their cutout to construction paper that is a contrast to their cutout's color. Then have students write a sentence across the bottom of their paper.

4. Have students share their cutouts with the class, and read aloud their sentences. Complete the assessment rubric on page 127.

Language Arts and Reading Standard: The student composes complete sentences in written texts and uses the appropriate end punctuation.
Visual Arts Standard: The student uses visual structures and functions of art to communicate ideas.
Bloom's Taxonomy: Comprehension—understanding information Synthesis—use old ideas to create new ones

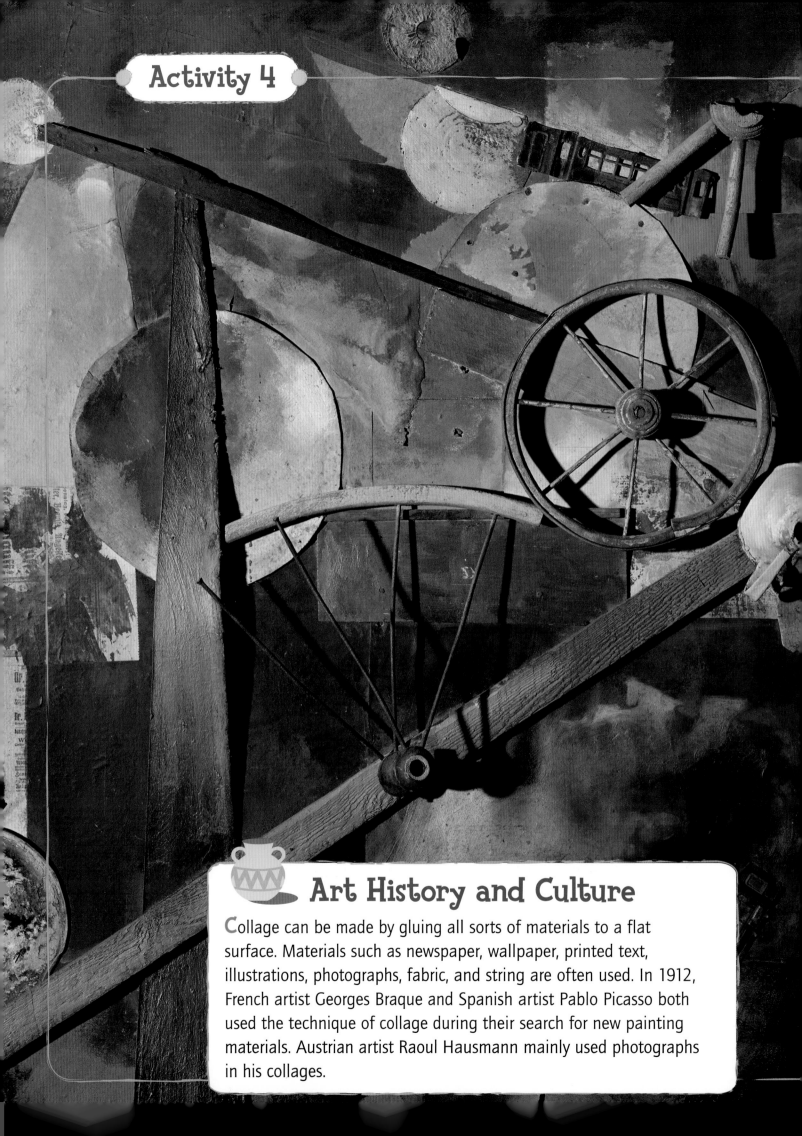

Art History and Culture

Collage can be made by gluing all sorts of materials to a flat surface. Materials such as newspaper, wallpaper, printed text, illustrations, photographs, fabric, and string are often used. In 1912, French artist Georges Braque and Spanish artist Pablo Picasso both used the technique of collage during their search for new painting materials. Austrian artist Raoul Hausmann mainly used photographs in his collages.

Magazine Collage

Objectives

Language Arts and Reading To reinforce studies of brainstorming by writing a story based on three random magazine images

Creative Expression To create a collage from three random images while applying the principle of unity

Bloom's Taxonomy Comprehension and Analysis

Prerequisites

• Study different methods of brainstorming, such as webbing, outlining, and free writing. Practice brainstorming, and then write a brief story.

• As a principle of art, identify unity as the feeling of wholeness or oneness achieved by properly using other elements and principles in art. Unity is achieved when variety (difference or contrast) and harmony (separate but related parts) work together. Study examples of collage (art made from gluing materials artistically).

Additional Applications

Science Environments: nature collage

Social Studies Landmarks: structures, buildings collage

Scale UP Have students select two realistic photos and one abstract photo to brainstorm and collage.

Scale BACK Have students choose one image to brainstorm and collage.

Materials

📄 copies of the "Brainstorming: Magazine Collage" Warm-Up, p. 99 • variety of precut magazine images (place in box) • notebook paper • pencils • blank paper • glue • colored pencils • materials such as fabric scraps, yarn, and newspaper

Alternate Materials: crayons • markers

1. Complete the **Warm-Up Activity.** Explain the concept of brainstorming, and discuss ways to brainstorm and why it is beneficial. Define the principle of unity as the feeling of wholeness or oneness achieved by properly using other art elements and principles. Explain to students that they will use brainstorming to create a unified collage from three unrelated pictures.

2. Have each student select three magazine images from the box without looking. Then have students choose a method of brainstorming, similar to the **Warm-Up,** to write a story connecting the three images.

3. Give each student a blank piece of paper on which to glue images to illustrate unity in art. See below for a visual example of unity (repeated shape). Have students use other materials in their collage, and tell them to draw in details to connect their images and tell a story.

4. Have students share their collages and stories with the class. Complete the assessment rubric on page 127.

Language Arts and Reading Standard: The student generates ideas for writing by using prewriting techniques such as drawing and listing key thoughts.
Visual Arts Standard: The student uses different media, techniques, and processes to communicate ideas, experiences, and stories.
Bloom's Taxonomy: Comprehension—interpret facts, compare, contrast Analysis—organization of parts

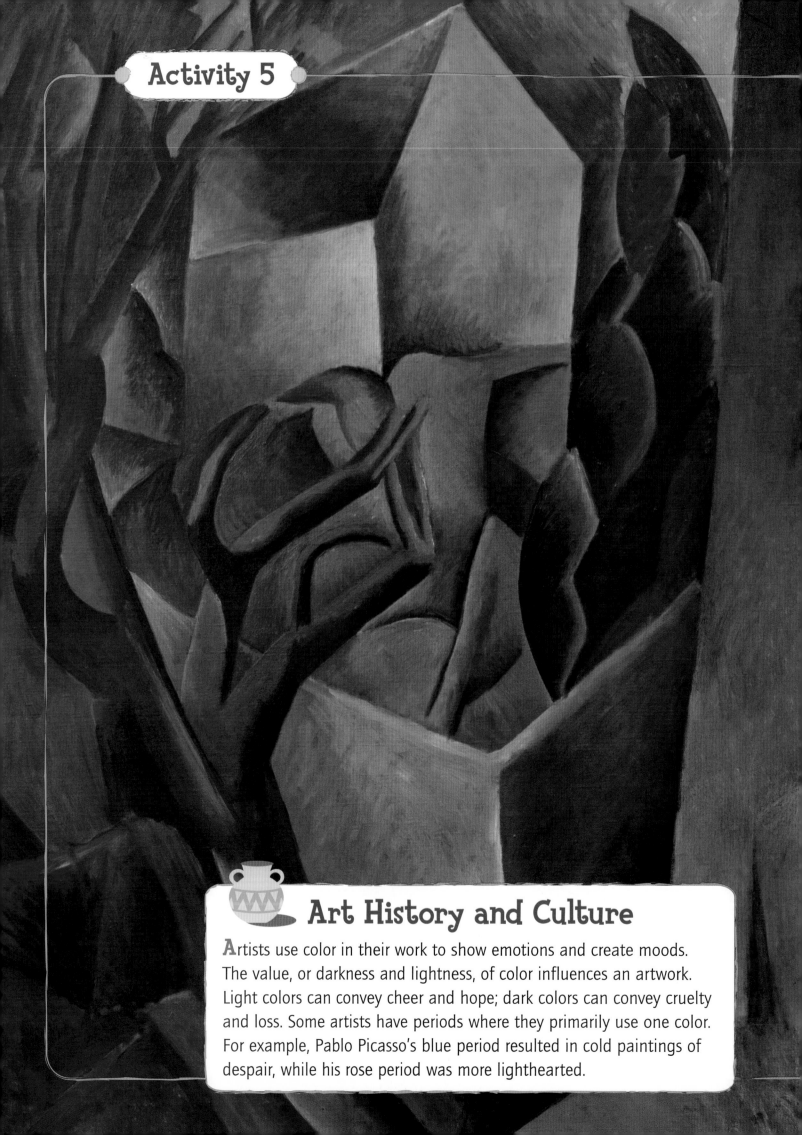

Art History and Culture

Artists use color in their work to show emotions and create moods. The value, or darkness and lightness, of color influences an artwork. Light colors can convey cheer and hope; dark colors can convey cruelty and loss. Some artists have periods where they primarily use one color. For example, Pablo Picasso's blue period resulted in cold paintings of despair, while his rose period was more lighthearted.

Narrative Drawing

Objectives

Language Arts and Reading To reinforce studies of descriptive writing by writing a description of a favorite memory, and then drawing a picture that tells the story of that memory

Creative Expression To create a drawing that uses shades of color to show feeling and depth, using the principle of value

Bloom's Taxonomy Knowledge and Application

Prerequisites

• Study traits of descriptive writing. Recognize that description can apply to both physical and mental things.

• Identify value as the principle of art that refers to the darkness and lightness of a hue. It is related to how much light a color reflects. Mix primary or secondary colors with white to create lighter shades, or with black to create darker shades.

Additional Applications

Science Seasons: describe seasonal colors

Social Studies Patriotic Symbols: describe symbols

Scale UP Have students write a short play about a school memory and design scenery based on the memory by using value.

Scale BACK Have students create a crayon drawing of a home memory.

Materials

📋 copies of the "Descriptive Writing: Narrative Drawing" Warm-Up, p. 100 • drawing paper • colored pencils or markers in light, medium, and dark shades

Alternate Materials: writing paper • crayons • construction paper

1. Complete the **Warm-Up Activity.** Review descriptive writing, and discuss its traits. Define the principle of value as the darkness and lightness of a hue, which is related to how much light a color reflects. Explain that different color shades can express different feelings. For example, pale colors usually convey calmness, while dark colors can express sadness or anger. Discuss what meanings other colors can convey.

2. Using colored pencils or markers, allow students a brief amount of time to practice creating different shades of one color.

3. Have students draw a picture based on the **Warm-Up.** Remind students to use the shades of colors that they believe best express the mood of their memory.

4. Have students share their drawings with the class, and explain their color choices. Complete the assessment rubric on page 127.

Language Arts and Reading Standard: The student writes to record ideas and reflections.
Visual Arts Standard: The student describes how people's experiences influence the development of specific artworks.
Bloom's Taxonomy: Knowledge—observation and recall of information Application—use methods, concepts, theories in new situations

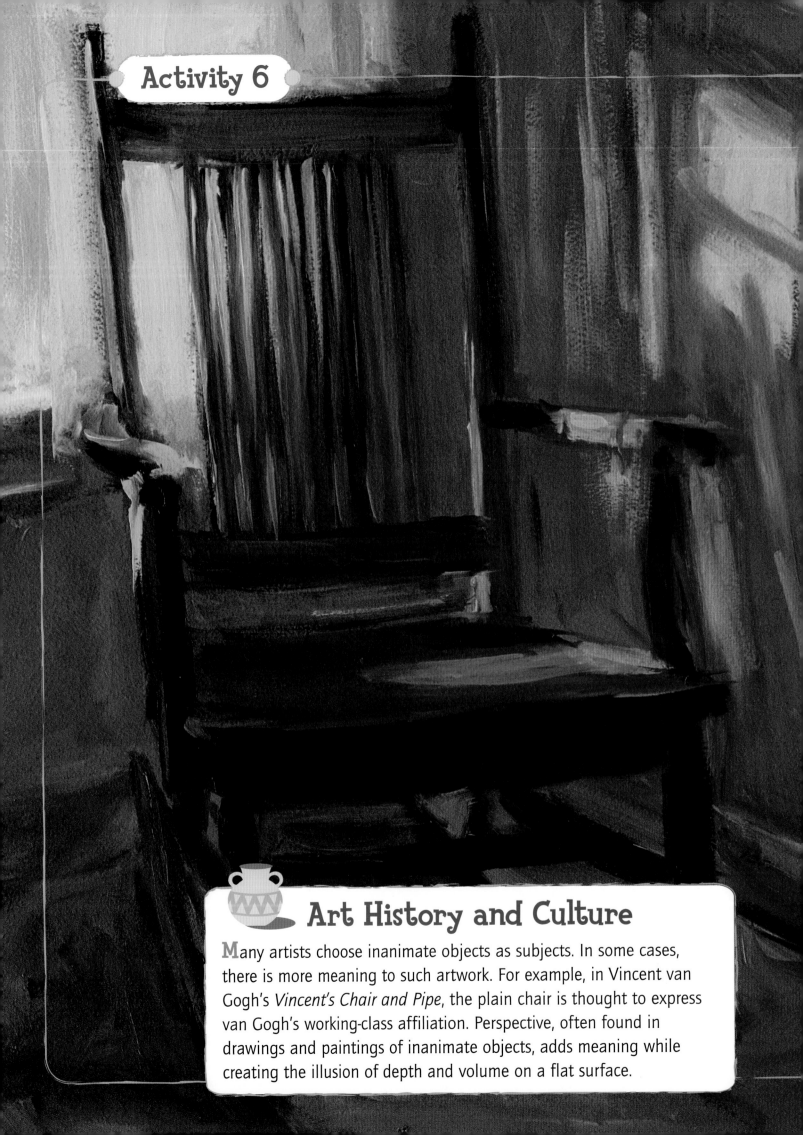

Art History and Culture

Many artists choose inanimate objects as subjects. In some cases, there is more meaning to such artwork. For example, in Vincent van Gogh's *Vincent's Chair and Pipe*, the plain chair is thought to express van Gogh's working-class affiliation. Perspective, often found in drawings and paintings of inanimate objects, adds meaning while creating the illusion of depth and volume on a flat surface.

Oil Pastel of a Chair

Objectives

Language Arts and Reading To reinforce studies of group writing by composing a group story about a chair, and then creating an oil pastel drawing based on the story

Creative Expression To draw a realistic chair by applying the principle of perspective

Bloom's Taxonomy Knowledge and Application

Prerequisites

- Explain the concept of group writing. Practice group writing with the whole class, and then in small groups.
- As a principle of art, identify perspective as a system used to create the illusion of depth and volume on a flat surface. Practice drawing classroom objects, such as chairs and desks, by using perspective.

Additional Applications

Math Volume: draw three-dimensional objects

Social Studies Latin America: types of chairs

Scale UP Have students create a three-dimensional paper chair.

Scale BACK Have students create a chair drawing using crayons, and then write a story on the chair's back side.

Materials

📄 copies of the "Group Writing: Oil Pastel of a Chair" Warm-Up, p. 101 • notebook paper • pencils • drawing paper • oil pastels
Alternate Materials: crayons • construction paper

1. Complete the **Warm-Up Activity.** Discuss group writing and the importance of each member contributing equally. Explain the principle of perspective as a system used to create the illusion of depth and volume on a flat surface. Analyze paintings of chairs, such as Alice Neel's *Loneliness*, and discuss their perspective. Explain that, to appear realistic rather than flat, objects must be drawn using perspective.

2. Have students get into groups of four. Although already completed individually, each student in a group should answer one question from the **Warm-Up** (Plan, Part 1). The goal is to combine everybody's input from the group to create the chair. Each group should

use their answers to write a detailed explanation of their chair. Each group should then select one group member to record the final version of their explanation.

3. Next, give each student drawing paper and oil pastels to create a version of the chair their group described. Remind students to use realistic perspective. (T̲T̲)

4. After each group member reads his/her part of the chair description aloud, have each student share his/her oil pastel drawing. Complete the assessment rubric on page 127.

Language Arts and Reading Standard: The student collaborates with other writers to compose, organize, and revise various types of texts, including letters, news, records, and forms.
Visual Arts Standard: The student uses visual structures and functions of art to communicate ideas.
Bloom's Taxonomy: Knowledge—knowledge of major ideas Application—use information

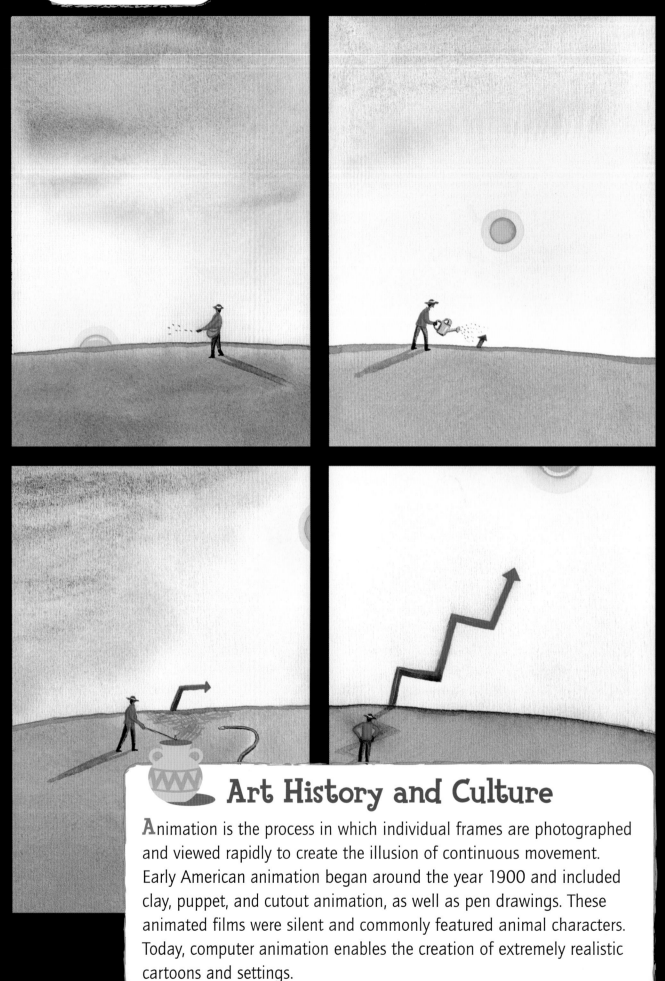

Art History and Culture

Animation is the process in which individual frames are photographed and viewed rapidly to create the illusion of continuous movement. Early American animation began around the year 1900 and included clay, puppet, and cutout animation, as well as pen drawings. These animated films were silent and commonly featured animal characters. Today, computer animation enables the creation of extremely realistic cartoons and settings.

Cartoon Storyboard

Objectives

Language Arts and Reading To reinforce studies of event sequence by creating a cartoon storyboard that shows the sequence of a story

Creative Expression To create cartoon characters and settings that exhibit distortion

Bloom's Taxonomy Knowledge and Analysis

Prerequisites

• Study event sequence. Discuss what typically happens in the beginning, middle, and end of a story. Look at and read appropriate cartoon strips. Recognize how cartoon storylines differ from other, more realistic stories.

• Identify distortion as the principle of art that is a deviation from normal or expected proportions. Look at distorted cartoon characters, and discuss how the artists changed human and/or animal features to create an imaginary character.

Additional Applications

Science Motion: cartoon movement

Social Studies Political and Social Change: political cartoons

Scale UP Have students create an animated flip book based on a storyboard.

Scale BACK Have students draw a distorted cartoon character.

Materials

📄 copies of the "Event Sequence: Cartoon Storyboard" Warm-Up, p. 102 • white and black paper • tape • glue • pencils • markers

Alternate Materials: crayons • drawing paper • construction paper 🔒 stapler and staples

1. Complete the **Warm-Up Activity.** Review event sequence, and use a cartoon strip to discuss the order of events. Show cartoon examples of film storyboards. Define the principle of distortion as a deviation from normal or expected proportions. Compare and contrast images of cartoon characters to realistic photographs.

2. Have students make eight storyboard frames by cutting white paper into strips, and cutting black paper into thinner strips.

If white paper strips are not long enough on their own, students can connect them with tape to make one very long piece. Have students glue the black strips to form frame borders.

3. Students' frames should each have a drawing to represent their cartoon's story, while showing the story's progression from beginning to end. Have students include short captions as needed within the frames of their storyboard.

4. Have students share their cartoon storyboards with the class, and explain the event sequence of their story. Complete the assessment rubric on page 127.

Language Arts and Reading Standard: The student writes to entertain such as compose humorous poems or short stories.
Visual Arts Standard: The student integrates visual, spatial, and temporal concepts with content to communicate intended meaning in their artworks.
Bloom's Taxonomy: Knowledge—knowledge of major ideas Analysis—identification of components

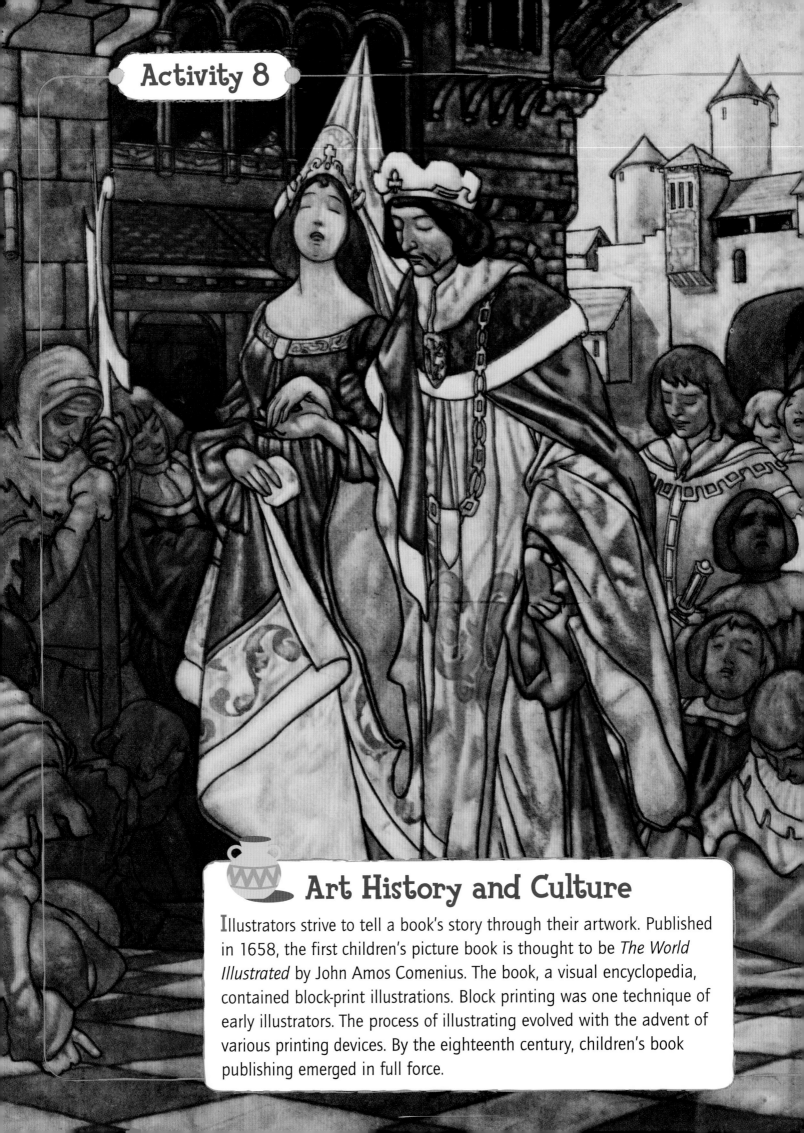

Art History and Culture

Illustrators strive to tell a book's story through their artwork. Published in 1658, the first children's picture book is thought to be *The World Illustrated* by John Amos Comenius. The book, a visual encyclopedia, contained block-print illustrations. Block printing was one technique of early illustrators. The process of illustrating evolved with the advent of various printing devices. By the eighteenth century, children's book publishing emerged in full force.

Story Illustration

Objectives

Language Arts and Reading To reinforce studies of publishing by completing the main stages of publishing a children's book

Creative Expression To create a children's book in which emphasis is incorporated into each illustration

Bloom's Taxonomy Comprehension and Synthesis

Prerequisites

• Describe the publishing process (writing, illustrating, binding), and how a book goes from an idea to print. Read a book that outlines publishing steps, or watch a video that shows the publishing process. Look at examples of handmade books.

• Identify emphasis as the principle of design that stresses one area in an artwork over another area. Artists use emphasis to draw a viewer's attention to a certain area.

Additional Applications

Math Spatial Visualization: planning a layout of shapes

Science Following Rules and Being Safe: children's safety book

Scale UP Have students create a book that illustrates the four food groups.

Scale BACK Have students bind their books using a hole punch and string.

Materials

copies of the "Publishing: Story Illustration" Warm-Up, p. 103 • legal-sized or larger white paper • pencils • markers • posterboard or cardboard • removable sticky shelf-liner paper **Safety** scissors • nontoxic rubber cement or glue sticks

Alternate Materials: fabric **Safety** hole punch • string

1. Complete the **Warm-Up Activity.** Review the main steps of publishing: writing, illustrating, and binding. Discuss the principle of emphasis, and look for emphasis in children's book illustrations.

2. Have students fold sheets of white paper in half. Have them write story text and draw illustrations on their pages. Remind students to emphasize one area, object, or person in their illustrations; for example, by changing the color or placement of something. Place glue on front of one half. Align back of other sheet and press to the half with glue. Repeat process to make as many book pages as needed.

3. Have students cut two posterboard squares slightly larger than book pages. Unroll liner paper and place posterboard squares on top. Leave enough space between squares for book's spine. Trace squares, leave two extra inches, and cut liner paper. Have them peel off liner backing and stick to posterboard. Fold liner around posterboard squares for book's cover. Place pages in middle of cover. Glue blank front and back pages to inside cover. Have students add a title and decorate the cover.

4. Have students share their books with the class. Read aloud to younger students if possible. Complete the assessment rubric on page 127.

Language Arts and Reading Standard: The student refines selected pieces frequently to "publish" for general and specific audiences.
Visual Arts Standard: The student employs organizational structures and analyzes what makes them effective or not effective in the communication of ideas.
Bloom's Taxonomy: Comprehension—understanding information Synthesis—relate knowledge from several areas

Life Event Colored-Pencil Drawing

Objectives

Language Arts and Reading To reinforce studies of finding needed information by interviewing someone to create a colored pencil drawing of an event in that person's life

Creative Expression To draw a picture that applies the principle of balance to visual weight

Bloom's Taxonomy Knowledge and Analysis

Prerequisites

• Study the process of finding needed information as well as how to find information using various methods, such as printed resources, computer research, surveys, and interviews.

• Identify balance as the principle of design that deals with visual weight in an artwork. In a drawing, balance can be achieved by giving all objects equal weight. This way one object is not emphasized over another.

Additional Applications

Math Bar Graphs: share information

Social Studies Appreciating Ethnic Diversity: interview someone of a different culture

Scale UP Have students create a picture time line showing events in a person's life.

Scale BACK Have students draw an event from their life.

Materials

📄 copies of the "Finding Needed Information: Life Event Colored-Pencil Drawing" Warm-Up, p. 108 (sent home in advance so students can complete interview) • drawing paper • colored pencils

Alternate Materials: pencils • crayons • markers

1. Complete the **Warm-Up Activity,** which must be done at least a day in advance so students can interview at home. Review how to find needed information, and discuss students' experiences while conducting their interviews. Define balance as the principle of design that deals with visual weight in an artwork. Visual weight does not refer to something that is physically weighed; it refers to what a viewer sees first in an artwork. Size, color, shape, and contour affect visual weight. Show examples of artwork with balance compared to artwork in which one element is emphasized over others.

2. Give each student drawing paper and colored pencils; have them create a drawing based on their interview.

3. While students add detail to their drawings, tell them they can achieve balance by paying equal attention to the background setting and any people or other subjects in their drawing. This drawing does not achieve balance.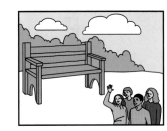

4. Have students share their drawings with the class, and explain the life event their drawing depicts. Complete the assessment rubric on page 127.

Language Arts and Reading Standard: The student generates questions and conducts research using information from various sources.
Visual Arts Standard: The student describes how people's experiences influence the development of specific artworks.
Bloom's Taxonomy: Knowledge—knowledge of dates, events, places Analysis—organization of parts

Art History and Culture

Flax, the oldest natural textile fiber, was used before 5000 B.C. for a variety of purposes, including to make linen. Cotton's origins have been dated between 5000 and 3000 B.C., while wool was used during the Stone Age. In approximately 1700 B.C., the Chinese introduced silk and kept its cultivation and creation secret for nearly 3,000 years. Rayon, the first human-made fiber, was developed in 1910.

Fabric-Collage Story Art

Objectives

Language Arts and Reading To reinforce studies of descriptive writing by creating a fabric collage based on a descriptive story

Creative Expression To create a fabric collage that achieves texture by using fabric and other textile materials

Bloom's Taxonomy Comprehension and Synthesis

Prerequisites

• Study the traits of descriptive writing. Practice writing brief descriptions for different purposes, such as to persuade or entertain.

• Identify texture as the element of art that refers to how things feel or look as if they might feel if touched. Look for different textures in the classroom, and analyze collage examples created using textured materials.

Additional Applications

Science Environments: textured collage of an animal's habitat

Social Studies Natural Resources: collage of natural materials

Scale UP Have students create a three-dimensional sculpture using scrap objects.

Scale BACK Have students cut shapes out of fabric and glue them to construction paper.

Materials

copies of the "Descriptive Writing: Fabric-Collage Story Art" Warm-Up, p. 109 • textured fabric scraps, such as corduroy, velour, burlap, felt, and so on • textile materials, such as yarn and string • construction paper • glue • scissors

Alternate Materials: scrap objects • safe, natural materials (found materials, not destroyed)

1. Complete the **Warm-Up Activity.** Review descriptive writing and how an effective description can be used to make writing more persuasive. Define the element of texture as how things feel or look as if they might feel if touched. Explain that collages can be made using objects that have texture, such as fabric and string. Look at and touch fabric collage examples.

2. Distribute construction paper to the students, and have them select fabric scraps and textile materials for their collage. Their textures can be realistic or exaggerated. Have students cut shapes to illustrate their persuasive stories from the **Warm-Up.**

3. Encourage students to practice their collage designs before gluing. Have them arrange their shapes in a way that best tells their story while keeping in mind that shapes include people, animals, and settings as well as objects. Have students glue scraps, materials, and shapes onto their construction paper.

4. Have students share their finished collages with the class, and read aloud their stories. Students should explain why they chose a realistic or an exaggerated texture to persuade. Complete the assessment rubric on page 127.

Language Arts and Reading Standard: The student writes to influence, such as to persuade, argue, and request.
Visual Arts Standard: The student selects and uses subject matter, symbols, and ideas to communicate meaning.
Bloom's Taxonomy: Comprehension—understanding information Synthesis—use old ideas to create new ones

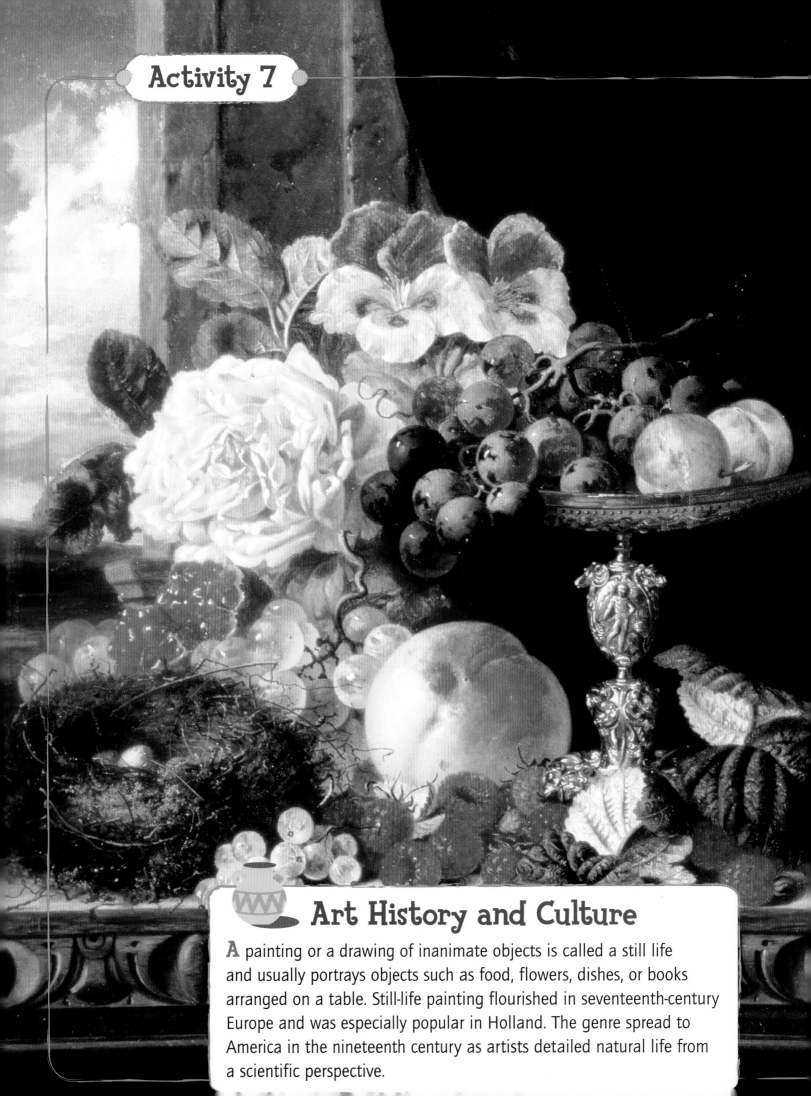

Art History and Culture

A painting or a drawing of inanimate objects is called a still life and usually portrays objects such as food, flowers, dishes, or books arranged on a table. Still-life painting flourished in seventeenth-century Europe and was especially popular in Holland. The genre spread to America in the nineteenth century as artists detailed natural life from a scientific perspective.

Sensory Delights Colored-Pencil Drawing

Objectives

Language Arts and Reading To reinforce studies of sensory details by creating a colored-pencil drawing of a table with food based on a sensory delights description

Creative Expression To draw objects in realistic proportion

Bloom's Taxonomy Knowledge and Analysis

Prerequisites

• Read literature that uses a lot of sensory detail, and discuss its traits. Practice writing a brief description based on each of the five senses.

• Identify proportion as the principle of art that is concerned with the size relationship of one part to another. Analyze examples of realistic still-life drawings or paintings, and practice proportional drawing.

Additional Applications

Math Conducting Experiments: taste testing

Science Plants: sensory description of a plant

Scale UP Have students create an oil painting inspired by the five senses.

Scale BACK Have students draw a table. Have them use construction paper to cut food shapes and other items, and glue them atop the table to create a still life.

Materials

📄 copies of the "Sensory Details: Sensory Delights Colored-Pencil Drawing" Warm-Up, p. 110 • drawing paper • colored pencils • erasers

Alternate Materials: oil paints • paintbrushes
[Safety!] paint thinner • paint trays • construction paper • glue [Safety!] scissors

1. Complete the **Warm-Up Activity.** Review sensory detail and how to describe the senses, such as how something tastes. Define proportion as the principle of art that is concerned with the size relationship of one part to another. Explain how to use realistic proportion when creating a still life. For example, a table set for dinner should show the silverware in the correct size in comparison to the plate. If beneficial for class discussion, set up an actual still life in your classroom.

2. Have students review their sensory description from the **Warm-Up.**

3. Tell students to use colored pencils to draw food on a table based on their description while applying correct proportion.

4. Have students share their drawings with the class, and read aloud their sensory descriptions. Complete the assessment rubric on page 127.

Language Arts and Reading Standard: The student writes to express, discover, record, develop, reflect on ideas, and to problem solve.
Visual Arts Standard: The student integrates visual, spatial, and temporal concepts with content to communicate intended meaning in their artworks.
Bloom's Taxonomy: Knowledge—observation and recall of information Analysis—organization of parts

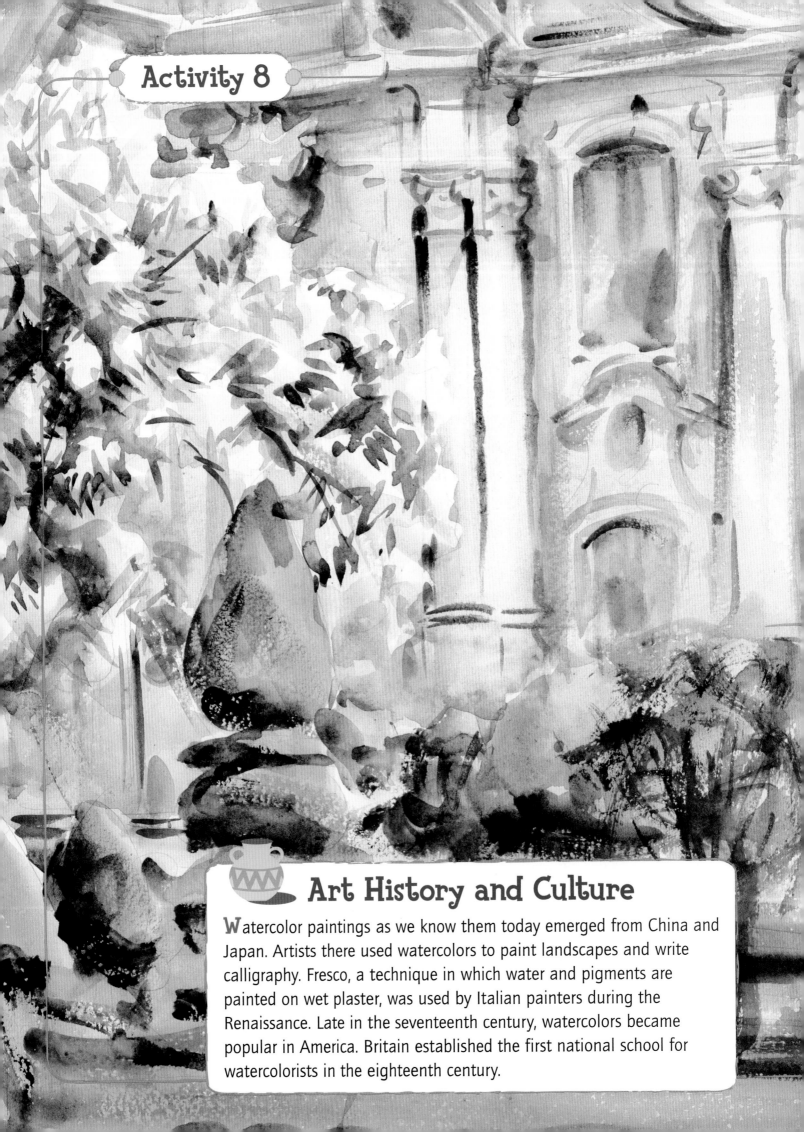

Art History and Culture

Watercolor paintings as we know them today emerged from China and Japan. Artists there used watercolors to paint landscapes and write calligraphy. Fresco, a technique in which water and pigments are painted on wet plaster, was used by Italian painters during the Renaissance. Late in the seventeenth century, watercolors became popular in America. Britain established the first national school for watercolorists in the eighteenth century.

Watercolor Painting of an Opinion

Objectives

Language Arts and Reading To reinforce studies of writing a Letter to the Editor by creating a watercolor painting showing the expressed opinion

Creative Expression To create a watercolor painting in which the viewer's eyes move through the painting by applying the principle of movement

Bloom's Taxonomy Comprehension and Evaluation

Prerequisites

• Read examples of Letters to the Editor. Compare and contrast some of the examples. Study the traits of a Letter to the Editor. Practice supporting your opinions by writing a Letter to the Editor.

• Recognize movement as the principle of art that leads a viewer's eyes through an artwork.

Additional Applications

Math Surveying: survey to support a Letter to the Editor

Social Studies Early Presidents and Politics: historical Letter to the Editor

Scale UP Have students create two paintings that express opposing opinions about the same issue.

Scale BACK Have students express opinion in a drawing.

Materials

📄 copies of the "Letter to the Editor: Watercolor Painting of an Opinion" Warm-Up, p. 111 • drawing and/or painting paper • pencils • watercolor paints • paintbrushes • water containers

Alternate Materials: crayons • construction paper

1. Complete the **Warm-Up Activity.** Discuss writing a Letter to the Editor, especially the types of issues that can be addressed in a Letter to the Editor. Define movement as the principle of art that leads a viewer's eyes through an artwork. For example, if a viewer 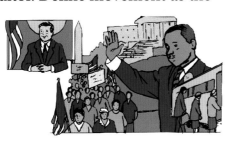 looks within all or most parts of a painting rather than focusing on just one part, the painting exhibits movement. Explain that paintings can show an opinion. Analyze artwork examples that show an opinion and have movement, such as Pablo Picasso's *Guernica.*

2. Using their plans from the **Warm-Up,** have students use a pencil to lightly draw a scene that expresses their opinion. Their drawings can be realistic or abstract, but must achieve movement. This can be done by creating a detailed scene so the viewer will have to look at several parts of the painting to understand the opinion.

3. Have students use watercolors to paint over their pencil drawing. 🆃🆃

4. Have students share their paintings with the class, and read aloud their Letters to the Editor. Students should explain how their opinions are shown in their paintings. Complete the assessment rubric on page 127.

Language Arts and Reading Standard: The student writes to influence, such as to persuade, argue, and request.
Visual Arts Standard: The student uses subjects, themes, and symbols that demonstrate knowledge of contexts, values, and aesthetics that communicate intended meaning in artworks.
Bloom's Taxonomy: Comprehension—order, group, infer causes Evaluation—verify value of evidence

Phonics

Letter *A* Object Drawing

FOCUS

Reading

(A)

(B)

(C)

Art

(F)

(G)

(H)

PLAN

1.

2.

FOCUS Directions

Read the following. Have students completely fill in the bubble of the best answer for each item.

Reading Which word starts with the letter *a*? A) orange, B) apple, or C) banana

Art Which can you use to draw a shape? F) paper, G) crayons, or H) eraser

PLAN Directions

1. Have students sketch at least three objects that start with the letter *a* in the first box.
2. Have students choose two shapes to draw in the second box, and fill the shapes with color.

LANGUAGE ARTS AND READING Art Connections

Name _____ **Date** _____

Event Sequence

Paper-Cup Animal Bank

FOCUS

Reading

 (A)

 (B)

 (C)

Art

 (F)

 (G)

 (H)

PLAN

1.

2. **Beginning**　　　　　　　**Middle**　　　　　　　**End**

3.

FOCUS Directions

Read the following. Have students completely fill in the bubble of the best answer for each item.

Reading The middle of a story comes A) after the end, B) after the beginning, or C) before the beginning.

Art In art, soft, hard, fuzzy, and rough are types of F) shapes, G) colors, or H) textures.

PLAN Directions

1. Have students draw one character from the story read aloud in class.

2. Have students put an X on the line where the character first appears in the story: beginning, middle, or end.

3. Ask students to describe their character's texture, and draw something they think has the same texture.

LANGUAGE ARTS AND READING Art Connections

Setting

Narrative Painting

FOCUS

Reading
- (A)
- (B)
- (C)

Art
- (F)
- (G)
- (H)

PLAN

1.

2.

FOCUS Directions

Read the following. Have students completely fill in the bubble of the best answer for each item.

Reading The place where a story takes place is called the A) setting, B) plot, or C) character.

Art The three primary colors are F) green, yellow, and blue, G) red, blue, and yellow, or H) red, orange, and blue.

PLAN Directions

1. Have students think of a place or a setting from a story, and write the name of the setting in the circle. Then have them write a person, an animal, or a thing's name on each line that could be found in that setting. A setting that includes characters and action is a scene.

2. Have students fill in each larger part of the color wheel with one primary color. In each smaller part, have them fill in the secondary color that the two primary colors next to it make when mixed together. Have students put a star next to each color they will use to paint their setting.

LANGUAGE ARTS AND READING Art Connections

Details

Clay-Figure Bell

FOCUS

Completely fill in the bubble of the best answer for each item below.

Language Arts

To make writing more detailed, use

- Ⓐ periods and commas.
- Ⓑ capital letters.
- Ⓒ adjectives and adverbs.
- Ⓓ quotation marks.

Art

In art, a form is an object measured by

- Ⓕ height only.
- Ⓖ width only.
- Ⓗ height and width.
- Ⓙ height, width, and depth.

PLAN

1. Write a detailed sentence to describe your clay-figure bell.

2. Think of a design for your figure's clothes.
 Think of your figure's facial features.
 Practice the design and features here.

Characterization

Character Greeting Card

FOCUS

Completely fill in the bubble of the best answer for each item below.

Reading

The people or animals in a story are the

- Ⓐ setting.
- Ⓑ plot.
- Ⓒ characters.
- Ⓓ dialogue.

Art

Unity is the principle of art that is

- Ⓕ concerned with the size relationship of one part to another.
- Ⓖ the feeling of difference among elements of art.
- Ⓗ the feeling of wholeness achieved by properly using elements and principles of art.
- Ⓙ concerned with difference or contrast.

PLAN

1. What kind of card will you make? Circle one or write in your own idea.

Holiday	Thank You	Get Well Soon
Birthday	Anniversary	Good Luck
Congratulations	Miss You	Other _____

2. Tell about your card's character.

Name _____ Hair Color _____ Eye Color _____

Favorites: Color _____ Hobby _____ Food _____

Girl or boy? _____ Human or animal? _____ Age _____

3. Draw your card's character.

4. What might your character say in the card?

Front of card _____

Inside of card _____

Autobiography

Life-Sized Paper Doll

FOCUS

Completely fill in the bubble of the best answer for each item below.

Language Arts

Writing about your own life is called
- (A) biography.
- (B) fiction.
- (C) autobiography.
- (D) poetry.

Art

Scale is the principle of art that
- (F) refers to size as measured against a standard reference.
- (G) is a variation from normal or expected proportions.
- (H) is concerned with difference or contrast.
- (J) leads a viewer's eyes through a work of art.

PLAN

1. Write ages from your past and future on the bottom lines of the time line; *0* (zero) and *Now* have been written for you. On each longer line above the time line, write a short sentence about what you were doing at that age or what you think you will be doing at that age.

0 _____ _____ _____ **Now** _____ _____ _____

2. Write a paragraph about what you think you will be doing when you are a grown-up.

Descriptive Writing

A Secret Place Painting

FOCUS

Completely fill in the bubble of the best answer for each item below.

Language Arts

Description can be used when writing

Ⓐ fiction.

Ⓑ nonfiction.

Ⓒ poetry.

Ⓓ all of the above.

Art

Emphasis is the principle of art that

Ⓕ refers to the darkness of a hue.

Ⓖ creates unity by stressing similarities of separate but related parts.

Ⓗ refers to the lightness of a hue.

Ⓙ stresses one area in an artwork over other areas.

PLAN

1. Choose a secret place, or invent a secret place you would like to have for your own. Write its name in the circle. Brainstorm details about your secret place, and write each detail on a line.

2. Write a descriptive paragraph about your secret place.

3. What is your favorite thing in or about your secret place?

Poetry

Self-Portrait

FOCUS

Completely fill in the bubble of the best answer for each item below.

Language Arts

Haiku, sonnets, and free verse are types of
- Ⓐ biography.
- Ⓑ fiction.
- Ⓒ poetry.
- Ⓓ essay.

Art

Proportion is the principle of art that
- Ⓕ deals with visual weight in an artwork.
- Ⓖ is concerned with the size relationship of one part to another.
- Ⓗ leads a viewer's eyes through a work of art.
- Ⓙ is used to create the illusion of depth and volume on a flat surface.

PLAN

1. On another sheet of paper, write as many words as you can to describe yourself. Use all or some of these words to write a short poem about yourself.

2. Reproduce this facial outline on drawing paper. Use a ruler to lightly draw lines to guide facial proportions. First draw a vertical line down the face's middle.

 Line 1 is a horizontal line across the face's middle.

 Line 2 is a horizontal line halfway between Line 1 and the face's chin.

 Line 3 is a horizontal line halfway between Line 2 and the face's chin.

 Line 4 is a horizontal line one-third of the way up between Line 1 and the top of the face.

 Line 5 is a horizontal line two-thirds of the way up between Line 1 and the top of the face.

 Do not draw facial features yet.

Line 5

Line 4

Line 1

Line 2

Line 3

Characters

Craft-Stick Puppet

FOCUS

Reading

- A
- B
- C

Art

- F
- G
- H

PLAN

1. []

2. []

FOCUS Directions

Read the following. Have students completely fill in the bubble of the best answer for each item.

Reading The characters in many stories are A) places, B) people, or C) ideas.

Art A ball is a F) form, G) shape, or H) color.

PLAN Directions

1. Have students create a character. Ask them, *How will your character look?* Have them draw an outline of their character's body or shape in the first box. Have students add a face and hair to their character, and then draw clothes on their character. Tell students to be sure to include anything else their character wears or holds.

2. In the second box, have students draw their character's favorite thing to do.

LANGUAGE ARTS AND READING Art Connections

Name _____ **Date** _____

Alphabet

Magazine-Cutout Alphabet Book

FOCUS

Reading

(A)

(B)

(C)

Art

(F)

(G)

(H)

PLAN

1.

A ___ C D E ___ G H ___ J K L ___

N O P ___ R S T ___ V W ___ Y Z

2.

c	n
r	w

FOCUS Directions

Read the following. Have students completely fill in the bubble of the best answer for each item.

Reading With what letter does the word *book* start? A) *d*, B) *p*, or C) *b*

Art Shapes are F) flat, G) round, or H) square.

PLAN Directions

1. Have students say the alphabet to themselves. Then have them fill in the missing letters of the alphabet.

2. Have students practice making alphabet-book pages. In each box, have them draw a shape or a picture of something that begins with the letter in the box.

LANGUAGE ARTS AND READING Art Connections

Beginning a Story

Crayon Drawing of a Story Scene

FOCUS

Reading	Art
(A)	(F)
(B)	(G)
(C)	(H)

PLAN

1.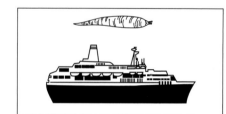

2.

FOCUS Directions
Read the following. Have students completely fill in the bubble of the best answer for each item.
Reading What usually happens at the beginning of a story? A) The characters leave, B) You meet the characters, or C) The characters have an argument.
Art In art, proportion deals with F) size, G) color, or H) shape.
PLAN Directions
1. Have students circle the picture that shows the carrot and the ship in the right proportion to each other.
2. Ask students to choose a story they have heard or read. In the box, have them draw a simple sketch in realistic proportion of what happens at the beginning of the story.

LANGUAGE ARTS AND READING Art Connections

Figurative Language

Fantasy Animal Painting

FOCUS

Completely fill in the bubble of the best answer for each item below.

Language Arts

A _____ is an example of figurative language.

- Ⓐ pronoun
- Ⓑ metaphor
- Ⓒ verb
- Ⓓ comma

Art

Variety is the principle of art that

- Ⓕ is concerned with difference or contrast.
- Ⓖ deals with visual weight.
- Ⓗ is concerned with size.
- Ⓙ leads a viewer's eyes through an artwork.

PLAN

1. Think of a fantasy animal, and name it. _____
 Use figurative language to describe your fantasy animal.

2. Write a simile. **Example:** The parrot is like a rainbow.

3. Write a hyperbole. **Example:** The whale is bigger than an ocean.

4. Pick contrasting colors for your fantasy animal. Color them here to see how they look together.

Descriptive Writing

Out My Window Collage

FOCUS

Completely fill in the bubble of the best answer for each item below.

Language Arts

Descriptive writing is best used when writing

Ⓐ a list.

Ⓑ a note.

Ⓒ a story.

Ⓓ an outline.

Art

Perspective is the principle of art that

Ⓕ stresses one area in an artwork over another area.

Ⓖ refers to the areas around an object.

Ⓗ is used to create the illusion of depth and volume on a flat surface.

Ⓙ is concerned with contrasting colors.

PLAN

1. Brainstorm about what you might see or dream about as you look out a window in the place where you live.

Out My Window

2. On another sheet of paper, write a brief descriptive paragraph using ideas from above. Include a lot of detail. Circle details that describe what is closest to the window. Underline details that describe what is farthest from the window.

LANGUAGE ARTS AND READING Art Connections

Fantasy

Fantasy Narrative Painting

FOCUS

Completely fill in the bubble of the best answer for each item below.

Language Arts

In fantasy writing, the story
- (A) is all false.
- (B) rhymes.
- (C) comes from imagination.
- (D) is all true.

Art

Distortion is the principle of art that
- (F) repeats a surface decoration.
- (G) refers to how things look as if they might feel if touched.
- (H) achieves wholeness or oneness.
- (J) varies from normal or expected proportions.

PLAN

1. Imagine your own fantasy world. Complete these sentences to describe it.

 The sky is _____.

 The ground is _____.

 The people _____.

 The animals _____.

 The plants _____.

 The weather _____.

 The buildings _____.

2. Use these lines to describe things in or things about your fantasy world that were not listed above. For example, does anything unusual happen in your fantasy world?

LANGUAGE ARTS AND READING Art Connections

Folklore

Papier-Mâché Folklore Mask

FOCUS

Completely fill in the bubble of the best answer for each item below.

Language Arts

In many cultures, folklore has been handed down mostly by

Ⓐ pictures.

Ⓑ oral storytelling.

Ⓒ printed books.

Ⓓ sculptures.

Art

Texture is the element of art that

Ⓕ is the path of a moving point through space.

Ⓖ can be measured by height, width, and depth.

Ⓗ refers to how things feel or look as if they might feel if touched.

Ⓙ is concerned with difference in color.

PLAN

1. Think of characters in a folklore story you have heard or read. Inspired by the story, think of a mask design, and sketch it here.

2. Texture on your mask will be achieved with papier-mâché. Look for and choose a safe and interesting texture in the classroom. Place this box on top of the texture, and use a crayon to create a rubbing of the texture within the box.

LANGUAGE ARTS AND READING Art Connections

Personal Narrative

Narrative Self-Portrait Book

FOCUS

Completely fill in the bubble of the best answer for each item below.

Language Arts

Personal narrative can be

(A) a short story.

(B) a poem.

(C) a play.

(D) all of the above.

Art

Balance is the principle of art that

(F) deals with visual weight in an artwork.

(G) refers to the darkness and lightness of a hue.

(H) is concerned with the size relationships.

(J) repeats elements and/or objects.

PLAN

1. Using this organizer, plan a personal narrative in which you are the main character. Think of a plot and details to support it. Your story will be used to make a book.

Plot: → **Detail:** → **Detail:** → **Detail:** → **Detail:**

2. Practice designing a balanced book page. Cut out the text and images below. Arrange them to create balanced page designs.

Visual Aids

School Sign

FOCUS

Language Arts

- (A)
- (B)
- (C)

Art

- (F)
- (G)
- (H)

PLAN

1.
[]

2.
[]

FOCUS Directions

Read the following. Have students completely fill in the bubble of the best answer for each item.

Language Arts An example of a visual aid is a A) word, B) map, or C) letter of the alphabet.

Art In art, making different things go together is called F) harmony, G) form, or H) shape.

PLAN Directions

1. Have students think of signs and visual aids they see in school. Ask them, *What words and/or symbols are used?* Have them think of what they want to say and show on their sign. Have students draw their ideas in the box.
2. Have students draw several shapes that their sign could be.

LANGUAGE ARTS AND READING Art Connections

Group Writing

Paper-Plate Puppet

FOCUS

Language Arts	**Art**
A	F
B	G
C	H

PLAN

1.

Ocean

2.

_____ _____ _____

_____ _____ _____

FOCUS Directions
Read the following. Have students completely fill in the bubble of the best answer for each item.
Language Arts Writing as a team is called _____ writing. A) before, B) story, or C) group
Art Artwork with height, width, and depth is a F) color, G) line, or H) form.

PLAN Directions
1. In each circle, have students draw something that could be in a story about the ocean. Have them choose one drawing to be their character in the class story about the ocean. The students will make a puppet of the drawing they choose.
2. Have students think about their ocean character. Have them write a word on each line to describe their character.

LANGUAGE ARTS AND READING Art Connections

Sentences

Wild Animal Cutout

FOCUS

Language Arts
- A
- B
- C

Art
- F
- G
- H

PLAN

1. Main Noun: _____

2. Main Verb: _____

3. Sentence: _____

4.

FOCUS Directions

Read the following. Have students completely fill in the bubble of the best answer for each item.

Language Arts Sentences are made of A) nouns and verbs, B) nouns, or C) verbs.

Art The open area around an object in an artwork is called F) texture, G) line, or H) space.

PLAN Directions

Have students think of a wild animal, such as a cheetah or a zebra. Have them "build" a sentence about that animal.

1. Have students write the main noun for their sentence on the line.
2. Ask students, *What will the animal do?* Have students write the main verb for their sentence on the line.
3. Have students use the main noun and main verb to write their sentence. This is the time to add any other details to their sentence, such as other people or things. Have them use the lines for practice.
4. In the box, have students sketch a drawing to go with their sentence.

LANGUAGE ARTS AND READING Art Connections

Brainstorming

Magazine Collage

FOCUS

Completely fill in the bubble of the best answer for each item below.

Language Arts

Which is *not* a way to brainstorm?

- ⒜ write words
- ⒝ complete a diagram
- ⒞ write a report
- ⒟ list ideas

Art

Unity is the principle of art that is

- ⒡ the feeling of wholeness achieved by properly using other art elements and principles.
- ⒢ the way a viewer looks at artwork.
- ⒣ concerned with size relationships.
- ⒥ concerned with contrast.

PLAN

1. Use this Venn diagram to brainstorm connections among three unrelated topics. Write words about each topic in its circle, such as *books* for *School.* Where two circles overlap, write what the two topics have in common. Where all three circles overlap, write only what all three topics have in common.

Library *School*

Bank

2. On separate paper, write a paragraph involving all three topics.

LANGUAGE ARTS AND READING Art Connections

Descriptive Writing

Narrative Drawing

FOCUS

Completely fill in the bubble of the best answer for each item below.

Language Arts

Descriptive writing can be used to write about the

Ⓐ past and present.

Ⓑ present and future.

Ⓒ future and past.

Ⓓ past, present, and future.

Art

Value is the principle of art that

Ⓕ stresses one area in an artwork over another area.

Ⓖ deviates from normal or expected proportions.

Ⓗ refers to how things feel or look as if they might feel if touched.

Ⓙ refers to the darkness and lightness of a hue.

PLAN

1. Choose a color you think best expresses each feeling below, and color it in the box after each word.

 happy ☐ sad ☐ angry ☐ sorry ☐

 peaceful ☐ tired ☐ love ☐ confused ☐

2. Think of a favorite memory. Describe the memory and how it makes you feel.

3. Write shades of color that best express your memory, such as pale blue.

 _____ _____ _____

LANGUAGE ARTS AND READING Art Connections

Group Writing

Oil Pastel of a Chair

FOCUS

Completely fill in the bubble of the best answer for each item below.

Language Arts

Working in groups can be useful when

- Ⓐ brainstorming.
- Ⓑ writing a story.
- Ⓒ evaluating written work.
- Ⓓ doing any writing activity.

Art

In art, perspective is a system that is

- Ⓕ used to create the illusion of depth and volume on a flat surface.
- Ⓖ concerned with the size relationship of one part to another.
- Ⓗ concerned with an artwork's visual weight.
- Ⓙ the area above, below, between, within, and around an object.

PLAN

1. Use these questions to write a paragraph to describe a chair of your own.

 What color is your chair, and what is it made of?

 What shape and size is your chair?

 What is your chair's function, or why was it made?

 Who sits in your chair, and what does he/she do while sitting in your chair?

2. Using perspective, sketch the chair you described above or a new chair.

LANGUAGE ARTS AND READING Art Connections

Event Sequence

Cartoon Storyboard

FOCUS

Completely fill in the bubble of the best answer for each item below.

Language Arts

At the end of a cartoon,

Ⓐ everything is usually resolved.

Ⓑ the characters are introduced.

Ⓒ nothing is resolved.

Ⓓ the characters are always happy.

Art

In art, distortion is

Ⓕ a way to measure against a standard reference.

Ⓖ the unity of similar and separate yet related parts.

Ⓗ the deviation from normal or expected proportions.

Ⓙ a repetition of elements and/or objects.

PLAN

Write a simple cartoon story in sequence.

1. Characters: Draw and name up to three cartoon characters of your own design. Each character should have at least one distorted feature.

_____ _____ _____

2. Setting: On separate paper, describe where your story occurs.

3. Plot and Event Sequence: Your storyboard will have eight frames. Write briefly what happens in each. Be sure to have a beginning, a middle, and an end.

Frame 1 _____ Frame 5 _____

Frame 2 _____ Frame 6 _____

Frame 3 _____ Frame 7 _____

Frame 4 _____ Frame 8 _____

LANGUAGE ARTS AND READING Art Connections

Publishing

Story Illustration

FOCUS

Completely fill in the bubble of the best answer for each item below.

Language Arts

The main steps of publishing a book are

Ⓐ writing, illustrating, and reading.

Ⓑ illustrating, reading, and binding.

Ⓒ writing, illustrating, and binding.

Ⓓ reading, binding, and selling.

Art

Emphasis is the principle of design that

Ⓕ refers to darkness and lightness.

Ⓖ deals with visual weight in an artwork.

Ⓗ deviates from normal or expected proportions.

Ⓙ stresses one area in an artwork over another area.

PLAN

Think about what to write for a children's book.

1. What will be the purpose of your book? Circle one.

 To teach something To retell a familiar story To tell a new story

2. What is your book's plot? Who will the characters be, and what will they do?

3. Children's books typically emphasize illustrations over text. How will you use pictures to tell your story?

4. On separate paper, practice your story's layout, including illustration sketches.

Forming an Opinion

Like and Dislike Marker Drawings

FOCUS

Language Arts
- A
- B
- C

Art
- F
- G
- H

PLAN

1. [blank box] F O

2. [blank box] F O

3. [blank box]

FOCUS Directions
Read the following. Have students completely fill in the bubble of the best answer for each item.
Language Arts An example of an opinion is A) the day of the week, B) how old you are, or C) your favorite food.
Art Lines can be F) straight only, G) curved only, or H) straight or curved.
PLAN Directions
1. Have students draw a tree. Ask them, *Is this a fact or an opinion?* Have students circle the letter F for fact or the letter O for opinion.
2. Have students draw something they like. Ask them, *Is this a fact or an opinion?* Have them circle F for fact or O for opinion.
3. Have students draw a straight line and a curved line. The lines should not be connected. Have students circle the straight line.

Visual Aids

Foam Tray Print

FOCUS

Language Arts

(A)
(B)
(C)

Art

(F)
(G)
(H)

PLAN

1.

2.

FOCUS Directions

Read the following. Have students completely fill in the bubble of the best answer for each item.

Language Arts Something that gives information by seeing it is a A) visual aid, B) song, or C) definition.

Art In a drawing, the areas around an object are called F) shape, G) space, or H) line.

PLAN Directions

1. Have students sketch a scene from a persuasive story read aloud in class to use as a visual aid to remember the story.

2. Tell students that their sketch will be used to make a two-color print. Have them choose two light colors and color one in each of the first two boxes. Next, have students choose two dark colors and color one in each of the last two boxes. Then have students circle one light color and one dark color to plan their print.

Considering an Audience

Cut-Paper Design

FOCUS

Language Arts
- A
- B
- C

Art
- F
- G
- H

PLAN

1. _____

2. _____

FOCUS Directions

Read the following. Have students completely fill in the bubble of the best answer for each item.

Language Arts Who is the audience for a diary? A) sisters, B) brothers, or C) the diary's writer

Art Repeating shapes or colors in an artwork create F) rhythm, G) space, or H) texture.

PLAN Directions

Tell students that when writing, language may change based on the audience. For example, they would probably not use the same words or way to say something (an expression) in a letter to a parent as in a letter to a friend. Ask students to think of how they would talk and write to the following audiences.

1. Have students write a family member's name on the first line. Have them use the next lines to write a sentence to his or her family member about what happened today at school. Have students draw a shape that tells about their sentence. The shape can be a real person, place, animal, object, or symbol for an idea or how they feel.

2. Have students repeat Step 1's process, but this time for a friend.

LANGUAGE ARTS AND READING Art Connections

Identifying Thoughts and Feelings

Family Portrait

FOCUS

Completely fill in the bubble of the best answer for each item below.

Language Arts

Which of the following is a good way to express thoughts and feelings?

Ⓐ writing a story
Ⓑ drawing a picture
Ⓒ writing a poem
Ⓓ all of the above

Art

Color is the element of art that

Ⓕ is the area surrounding an object.
Ⓖ comes from reflected light.
Ⓗ is a moving point through space.
Ⓙ is concerned with visual weight.

PLAN

Color can show feelings, and it can remind us of people.

1. On the line next to each color, name a person that color reminds you of.

red _____ blue _____

yellow _____ green _____

purple _____ orange _____

black _____ white _____

2. Choose one person you named above, and write about that person in a brief paragraph on a separate sheet of paper. Explain why that color makes you think of him or her.

Finding Needed Information

Life Event Colored-Pencil Drawing

FOCUS

Completely fill in the bubble of the best answer for each item below.

Language Arts

If you need information about a person you know, you should

Ⓐ do an interview.

Ⓑ read a newspaper.

Ⓒ use an encyclopedia.

Ⓓ make a list.

Art

Balance is the principle of design that

Ⓕ leads a viewer's eyes through a work of art.

Ⓖ describes contrast.

Ⓗ deals with visual weight in an artwork.

Ⓙ repeats elements of art.

PLAN

1. Name major events that happen in many people's lives.

2. Choose one life event and circle it. Think of a person you know to interview about that event. Write his or her name here.

3. On a separate sheet of paper, write five questions to take home and ask in your interview.

4. Is this image a good example of balance? Circle *Yes* or *No*.

Yes

No

LANGUAGE ARTS AND READING Art Connections

Descriptive Writing

Fabric-Collage Story Art

FOCUS

Completely fill in the bubble of the best answer for each item below.

Language Arts
Using description can make persuasive writing

- (A) shorter.
- (B) more convincing.
- (C) more scientific.
- (D) easier.

Art
Texture is the element of art that is

- (F) how things feel or look as if they might feel if touched.
- (G) a repeated decoration.
- (H) a three-dimensional object measured by height, width, and depth.
- (J) the darkness or lightness of a hue.

PLAN

1. Pretend you did not do your homework. Use this web to brainstorm excuses to tell your teacher. Exaggeration is often used in descriptive writing, so feel free to exaggerate your excuses.

2. Choose one homework excuse. You have to convince your teacher to believe the excuse. On a separate sheet of paper, write a descriptive story with details that persuade.

3. Think of at least one texture to suggest the feeling or excuse from your story. Decide if a real or an exaggerated texture would be more persuasive. Name the texture(s) here.

Why I Do Not Have My Homework

LANGUAGE ARTS AND READING Art Connections

Sensory Details

Sensory Delights
Colored-Pencil Drawing

FOCUS

Completely fill in the bubble of the best answer for each item below.

Language Arts

Which of the following is not one of the five senses?

- Ⓐ touch
- Ⓑ sight
- Ⓒ thought
- Ⓓ smell

Art

Proportion is the principle of art that is

- Ⓕ concerned with contrast.
- Ⓖ the feeling of wholeness or oneness.
- Ⓗ used to create the illusion of depth.
- Ⓙ concerned with the size relationship of one part to another.

PLAN

1. Think of some of your favorite foods. Write the name of each food in the *Food* column. For each sense that applies, write a sensory detail in the corresponding column.

Food	Sight	Touch	Smell	Taste	Sound
___	___	___	___	___	___
___	___	___	___	___	___
___	___	___	___	___	___
___	___	___	___	___	___

2. On a separate sheet of paper, write a description using your sensory details.

3. Correct proportion is used in realistic artwork. With two or more objects, consider their size difference. Draw an apple and a vase in correct proportion.

Letter to the Editor

Watercolor Painting of an Opinion

FOCUS

Completely fill in the bubble of the best answer for each item below.

Language Arts

In a Letter to the Editor, you should write

- (A) stories.
- (B) opinions.
- (C) poems.
- (D) riddles.

Art

Movement is the principle of art that

- (F) creates unity by stressing similarities of separate but related parts.
- (G) deviates from normal or expected proportions.
- (H) leads a viewer's eyes through a work of art.
- (J) focuses on one area of an artwork over another.

PLAN

1. List some issues you have an opinion about. Issues can deal with schools, cities, states, countries, the world, the environment, politics, and so on.

2. Select one issue from above to write about in a Letter to the Editor. Complete this outline.

 I. Introduction and topic of letter

 II. Statement of opinion

 III. Support for opinion

 IV. Suggestion(s) for action

 V. Conclusion

3. On a separate sheet of paper, write your Letter to the Editor.

Technique Tips

Joining Two Pieces of Clay

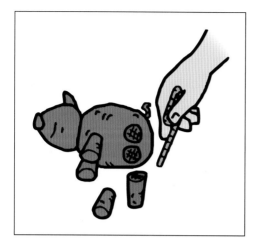

Score, or scratch, both pieces
so they will stick together.

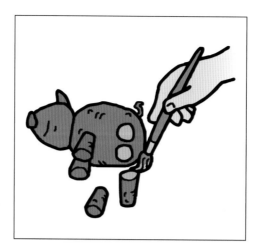

Attach the pieces with some *slip,*
which is watery clay.

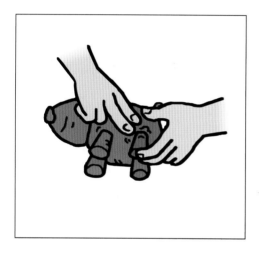

Squeeze the two pieces together.
Smooth the edges.

Technique Tips

Papier-Mâché

Create a supporting form, if needed. Forms can be made of almost anything. Masking tape can be used to hold the form together.

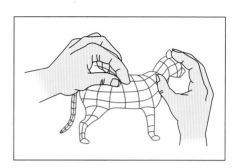

Tear newspaper or paper into strips. Dip the strips into paste, or rub the paste onto the strips using your fingers. Use wide strips for wide forms and thin strips for small forms.

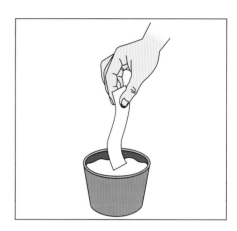

Apply several layers of strips, applying each layer in a different direction. Smooth over rough edges with your fingers. When your sculpture dries, you can paint it.

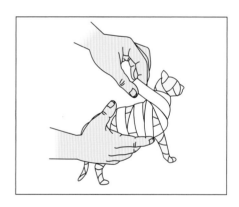

Technique Tips

Paper Sculpture

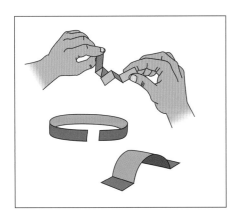

You can cut, curl, fold, and bend paper strips to make paper sculptures.

Cut paper strips to make facial features, hair, or other things including shapes, tunnels, and stairs.

Technique Tips

Oil Pastels

Oil pastels are colors that are mixed with oil and pressed into sticks. They look like crayons, but are softer and break more easily. When you press down hard with oil pastels, your pictures will look painted. Colors can be mixed or blended by smearing them using a tissue or your finger. Oil pastels can be messy; wash your hands with soap and water after using them.

Oil pastels come in bold colors. You can use oil pastels to color over other media, such as tempera or crayon. Then you can scratch through this covering to create a design.

Technique Tips
Printmaking

1. Using a pencil, tip of a paper clip, or another object, draw or sculpt a design on a flat piece of plastic foam.

2. Put a small amount of ink or paint on a flat solid surface. Roll a brayer back and forth in the ink or paint until there is an even coating on the brayer. Roll the brayer over your design.

3. Press paper onto tray with design. Rub gently over paper to create the print of your design.

4. Lift paper to reveal print. Clean tray to use another color or colors to repeat process as needed or desired.

Technique Tips

Watercolor

1. Fill water containers halfway. Dip your paintbrush in the water. Wipe your paintbrush on the inside edge of the container. Then blot it on a paper towel to get rid of extra water. With your paintbrush, add a drop of water to each watercolor cake and stir. Remember to clean your paintbrush whenever you change colors.

2. Always mix colors on a palette. Put some of each color that you want to mix on the palette. Then add the darker color a little at a time to the lighter color. Change your water when it gets too dark.

3. To create lighter values, add more water. To darken a value, add a tiny amount of black. If you have painted something too quickly, add water to the paint on the paper and blot it with a clean paper towel.

4. Use a thin pointed paintbrush to paint thin lines and details. For thick lines or large areas, press firmly on the tip or use a wide paintbrush.

5. For a softer look, tape your paper to the table with masking tape. Use a wide paintbrush to add water to the paper, working in rows from top to bottom. This is a wash. Let the water soak in a little. Painting on wet paper will create a soft or fuzzy look. For sharper forms or edges, paint on dry paper, using only a little water on your paintbrush.

6. Wash your paintbrushes when you are finished. Reshape the bristles. Store paintbrushes with the bristles up.

Technique Tips

Drawing

Pencil Basics

For darker values, use the side of your pencil lead, press harder, and go over areas more than once. You can add form to your objects using shading.

Colored Pencils

You can blend colors with colored pencils. Color with the lighter hue first. Gently go over the light hue with the darker hue until you get the hue you want.

You can create shadows by blending complementary colors.

Technique Tips

Painting

Paintbrush Care

Rinse your paintbrush in water between colors. Blot the paintbrush dry on a paper towel. Clean the paintbrush when you are finished painting.

1. Rinse the paintbrush in clean water. Gently wash the paintbrush with soap.

2. Again rinse the paintbrush well. Then blot the paintbrush dry.

3. Gently smooth and shape the bristles.

4. Store paintbrushes with bristles up.

Technique Tips

Painting

Tempera

Wet your paintbrush in a water container. Wipe off extra water using the inside wall of the container and blot the paintbrush on a paper towel.

Mix colors on a palette. Put some of each color that you want to mix on the palette. Add darker colors a little at a time to lighter colors. To create a tint, mix a small amount of a hue into white. To create a shade, mix a small amount of black into a hue.

Use a thin, pointed paintbrush to paint thin lines and details.

Use a wide paintbrush to paint large areas.

Technique Tips

Working with Clay

Squeeze, pull, and shape the clay to make it soft. Form clay into an oval shape.

Squeeze and pinch.

Pinch and pull.

· ·

Sewing a Book

1. Find the center of the fold and make a mark. Measure 1″ above and below the center mark.

2. Use a tapestry needle and poke holes through your marks.

3. Thread your needle and go through the top hole from the outside of your book and back through the center hole. Cut your thread so that you can tie both ends together.

4. Repeat for the bottom of your book.

Elements of Art

Art is a language. The words of the language are the elements of art.

Line

Shape

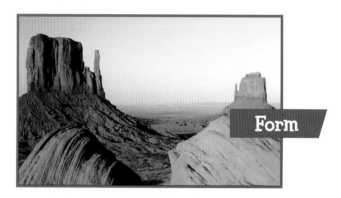

Form

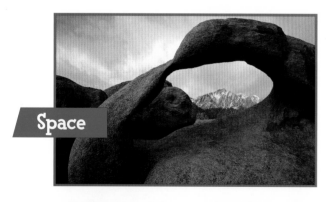

Space

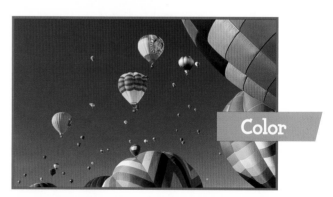

Color

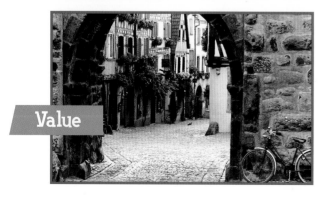

Value

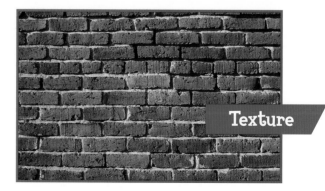

Texture

Principles of Art

Artists organize these words using the principles of art.

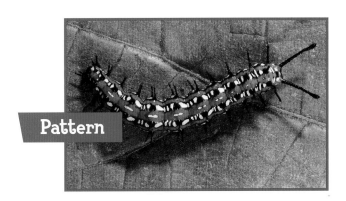

Pattern

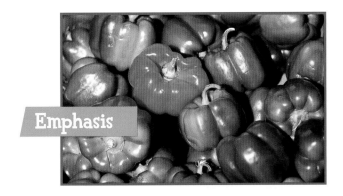

Rhythm

Balance

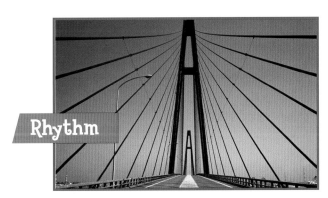

Emphasis

Harmony

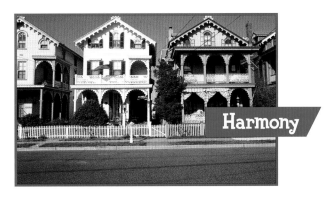

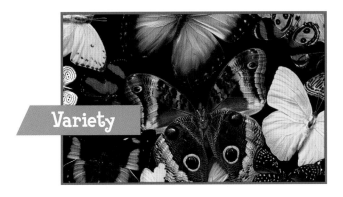

Variety

Unity

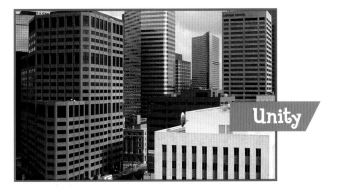

Accessibility

The visual arts play a vital role in challenging and eliminating many stereotypes about persons with disabilities. The skills gained in visual arts often result in increased confidence and ability in other academic subjects. Arts-based learning is often effective because of the ways it engages the multiple senses and abilities of students. The arts also give students an opportunity to explore, express, and celebrate their identities. The first step in developing the competence to skillfully instruct students with disabilities is to develop an understanding of each student's disability.

School-Level Resources

Resources at the school level include special education staff and related service providers who have contact with the student, such as occupational and physical therapists. These staff members can provide insight into the student's learning strengths and needs as well as his or her physical and emotional development. They can also provide helpful suggestions on how a particular art medium or tool can be made accessible to a particular student.

Another valuable resource is the student's Individualized Education Plan (IEP). This plan exists for every student receiving special education services and provides information about learning styles, needs, and modifications. The Individuals with Disabilities Education Act (IDEA) requires that all regular education teachers of students with disabilities have access to the student's IEP and are provided with support in implementing modifications to the general curriculum.

Disability Education Organizations

The National Dissemination Center for Children with Disabilities (NICHCY) provides information on special education law, links to state disability agencies, and concise information on specific disabilities. The Council for Exceptional Children (CEC) produces a number of publications for parents and teachers, including an online newsletter, journals *(Exceptional Children* and *Teaching Exceptional Children)*, books, and videos.

Art Education and Disability Organizations

VSA arts has been designated as the National Coordinating Agency of Arts in Learning for Persons with Disabilities by the United States Congress. They fulfill this role through a vast network of state affiliates. *VSA arts* produces art and disability awareness curricula and showcases the work of students with disabilities by regularly sponsoring national calls for art. They also provide access to the work of artists with disabilities.

The Special Needs Interest Group of the National Art Education Association (NAEA) meets annually at the NAEA convention to discuss the best practices in art education for students with special needs. This group publishes a column in the bimonthly publication, *NAEA News*.

Adapting the Art Experience for Students with Disabilities

Effective adaptations are individualized and begin with knowledge of a particular student's learning strengths and needs. Teachers may choose to adapt art media, instructional strategies, and/or physical space, depending upon the situation. Begin by observing students in an introductory art experience. If a student has difficulty with an art task, try to determine the source of the difficulty. Consult with other school staff and use some of the references listed in this article to determine what is most appropriate for the student and the situation.

References

Arts Education Partnership (2002). *Critical Links: Learning in the Arts and Student Academic and Social Development.* Washington, D.C.: Arts Education Partnership.

Anderson, F. E. (1994). *Art-Centered Education and Therapy for Children With Disabilities.* Springfield, IL: Charles C. Thomas.

Andrus, L. (1994). Art education: An equalizing force in the inclusion setting. In *Inclusion: Buzzword or hope for the future?* Annual Monograph of the New York State Council of Educational Associations.

Andrus, L. (2001). Teaching Urban Children With Special Learning Needs: What We've Learned in The Art Partners Preservice Fieldwork Program. [On-line]. Available: **www.artpartnersprogram.com/readingroom/**

Blandy, D. (1989). Ecological and normalizing approaches to disabled students and art education. *Art Education, 42* (3), 7–11.

Henley, D. (1992). *Exceptional Children: Exceptional Art: Teaching Art to Special Needs.* Worcester, MA: Davis Publications.

Nyman, A. L. and Jenkins, A. M. (Eds.). *Issues and Approaches to Art for Students With Special Needs.* Reston, VA: National Art Education Association.

Safety

Elementary teachers are responsible for the safety of their students. Specific safety standards should be diligently followed in order to assure that neither the students nor the teachers are injured by the use of unsafe art materials. Elementary teachers should do two things to prevent problems: keep all toxic and hazardous materials out of the classroom, and know how to use all materials safely.

The Arts and Crafts Materials Institute developed a voluntary program to provide a safe standard for materials used by children. Products bearing the labels AP (Approved Product) or CP (Certified Product) have been tested by toxicologists at major universities and have been deemed safe for children to use. The HL (Health Label) on art products indicates that these products are appropriate to use with students 12 years old or older under the supervision of a teacher. Products with HL labels are *not* safe for elementary students.

Safe Art Materials

The following are guidelines for choosing and using basic art materials in a safe manner.

- Use only water-soluble AP- or CP-designated markers. Never use toxic permanent markers in the elementary classroom. The use of scented markers is also discouraged, as it teaches students to sniff or smell materials.
- Use only dustless chalk. Most chalks are better used outside for sidewalk art.
- Crayons should bear the AP or CP label to ensure that no lead is present in these materials. Consider using oil pastels.
- Use only liquid tempera and/or watercolor paints. If you must use powdered tempera paints, wear a dust mask and mix these outside. Have the paints ready before the students enter the classroom. Do not use spray paints or fixatives.
- Use only water-soluble printer's inks. Do not use solvent-based inks.
- Use pencils to carve into unused foam trays for printing blocks. Do not use mat knives or other sharp instruments.
- Use only school paste or white glue for adhering papers. Do not use rubber cement or wallpaper paste unless it bears the AP or CP label. Do not use solvent-based glue.
- Use premixed, moist clay for sculpture and pottery. Do not allow students to take home any unfired clay. Paint clay pieces with tempera or watercolor paints. Do not allow students in the room where a kiln is firing. Use only nontoxic glazes.
- Use pencils, craft sticks, or other blunt tools to carve clay. Soapstone should not be used for carving in a closed environment.
- Read labels carefully on pastes used for papier-mâché. Some pastes contain pesticides or preservatives that are extremely harmful.
- Use blunt needles and loosely woven fabrics, such as burlap, for stitchery. Blunt metal tapestry needles are safe if students are supervised.
- Do not accept or use old art materials. If the materials do not bear the current safety codes, properly dispose of them.
- Allow no food or drink in the room where art activities are being conducted.
- Use plastic containers for washing and storing paintbrushes.
- Paper cutters should not be used by elementary students. The paper cutter should be kept out of students' reach and left in a locked position with the blade turned to the wall.
- Do not use commercial dyes; use vegetable or natural dyes, such as flowers, teas, nut shells, and onion skins.

Student Guidelines

The following are rules for students to follow while completing art activities.

- Use art materials only in your artwork.
- Keep art materials out of your mouth, eyes, and ears.
- Use scissors and other sharp tools carefully. Keep your fingers away from the cutting blades.
- Wash your hands after using art materials.
- Wear an art shirt or smock to protect your clothes.
- Always follow your teacher's directions.

References
Babin, A., Editor. *Art Hazards News,* Vol. 17, No. 5, 1994.
Babin, A.; Peltz, P. A.; and Rossol, M. "Children's Art Supplies Can Be Toxic." New York: Center for Safety in the Arts, 1992.
McCann, Michael. *Artist Beware.* NY: Watson-Guptill Publications, 1979.
McCann, Michael. "Hazards in the Arts." NY: Center for Safety in the Arts, 1989.
Qualley, Charles A. *Safety in the Art Room.* MA: Davis Publications, Inc., 1986.

Assessment

Rubrics

A rubric is a scaled set of criteria that clearly defines for the student and the teacher what a range of acceptable and unacceptable performances looks like. A rubric provides students with expectations about what will be assessed, as well as standards that need to be met. Using rubrics to evaluate artwork increases consistency in the rating of performance, product, and understanding.

Criteria are necessary to ensure reliability, fairness, and validity in evaluation. When developing a rubric, consider the qualities or features by which you can determine if the student has produced an excellent response to the assessment task. Once you have related the task to specific goals for students, you must evaluate what the students must do to show that they are working toward or achieving those goals. Outline expectations for each task. It is helpful to have samples or models of student work that exemplify the criteria you might use in judging each task. Students should see and understand the rubric before completing the task.

Portfolios

A portfolio is a collection of a student's work that exhibits the student's planning, progress, and problem-solving skills in many areas of art. There are two primary styles of portfolios: the exploratory portfolio and the exhibition portfolio. An exploratory portfolio is a collection of skills the student is currently working on and can include sketches and gesture drawings. Unfinished artworks may be included. Exhibition portfolios are used by students and professionals for jobs, display, college admission, scholarships, and commission work. They consist of a collection of the student's best artwork that displays a variety of skills, subjects, and techniques.

The use of a portfolio encourages collective assessment and focuses on student strengths instead of weaknesses. It builds self-esteem in students through successes with a collection of artwork and develops strong work habits in students.

Art Criticism and Aesthetic Perception

The four-step process of art criticism provides a procedure that students can use to objectively study their own art products, as well as the works of others. During the first two steps, *Describe* and *Analyze,* students are asked to collect data objectively. During the third step, *Interpret,* students speculate about the meaning of the work based on the data collected; they make a hypothesis about the idea, emotion, or mood expressed by the artist. During the fourth step, *Decide,* the students offer their aesthetic judgment about the artwork.

How to Use this Rubric

Make one copy of the generic Rubric on page 127. Write the four art criticism questions on the bottom of the page by using the following criteria.

Describe What did the student do to participate? (For example, *What repeating color, shape, or texture did you use to create harmony in your artwork?*)

Analyze How did the student's participation reveal or connect with the subject-area objective? (For example, *How did you incorporate integers into your game board?*)

Interpret Relate the student's participation in this activity to real life. Focus on the big picture. (For example, *What feelings do you think are expressed in your photosensitive picture?*)

Decide Decide whether student participation was effective, how it could be improved, and so on. (For example, *Did you choose the best symbol to represent your historic figure in the pectoral pendant? If you were to repeat the activity, what other symbol would you use?*)

Copy and distribute the rubric to students. Explain the criteria upon which the activity will be judged. When students complete the activity, have them fill in the **Student** column of the rubric based upon the rating scale provided and answer. Fill in the **Teacher** column of the rubric, and discuss the evaluation individually with students. Have the students save their artwork in a portfolio if appropriate.

Rubric

Name _____ Date _____ Project _____

Criteria	Student	Teacher
1. **Craftsmanship** Neatness, concern for work quality		
2. **Dedication to Task** Working to best ability, patience, concentration, and time management		
3. **Creative Expression** Trying a new idea, skill, or solution to the problem; expanding an idea; creative use of ideas, art materials, or tools		
4. **Accurate Observation and Recording** Attention to detail, proportion		
5. **Use of Art Elements and Principles** Line, shape, color, texture, form, space, value, pattern, rhythm, balance, emphasis, harmony, variety, unity		
6. **Use of Subject-Area Principle** (Varies with individual project objective.)		
7. **Appreciation** Understanding and appreciation of self and others through art history and culture		
8. **Aesthetic Growth** Interpret, evaluate, and justify artistic decisions		

Rating Scale
1 **Not Satisfactory** Some attempt to explain concept; shows little or no understanding
2 **Needs Work** Shows a moderate understanding of concept, ideas, processes
3 **Qualified** Meets minimal standards
4 **Better Qualified** Shows strong understanding of concept, ideas, processes
5 **Exceptional** Demonstrates excellence in understanding; identifies all important elements and may include examples

Portfolio Assessment

Did you accomplish your goals with this artwork? _____

Would you choose this artwork for your portfolio? Why or why not? _____

What do you like about this artwork? _____

What did you learn from doing this artwork? _____

Art Criticism

Describe _____

Analyze _____

Interpret _____

Decide _____
